**Great Graphics
on a Budget**

Creating Cutting-Edge
Work for Less

**Great Graphics
on a Budget**

Creating Cutting-Edge
Work for Less

written + designed by
dixonbaxi
design for life

GLOUCESTER MASSACHUSETTS

ROCKPORT
PUBLISHERS

**Great Graphics
on a Budget**

Creating Cutting-Edge
Work for Less

Acknowledgments

For Jill and Rachel

First published in the
United States of America by
Rockport Publishers, Inc.
33 Commercial Street
Gloucester, Massachusetts
01930-5089
Telephone: (978) 282-9590
Fax: (978) 283-2742
www.rockpub.com

Library of Congress
Cataloging-in-Publication Data
Dixon, Simon
 Great graphics on a budget:
 creating cutting edge work for less /
written + designed by Simon Dixon
and Aporva Baxi; dixonbaxi.
 p. cm.
 ISBN 1-56496-948-7
 1. Commercial art—Economic aspects.
 2. Commercial art—Practice. I. Baxi, Aporva.
II. dixonbaxi (art Gallery) III. Title. IV. Title:
Creating cutting edge work for less.
NC1001.6 .D57 2003
741.6'068'1—dc21 2002153669

ISBN 1-56496-948-7

10 9 8 7 6 5 4 3 2 1

Design: dixonbaxi

Printed in China

First and foremost, thanks to our editor,
Kristin Ellison, for approaching us to do this
book and for showing a seemingly endless
amount of patience!

Thanks to all those within the international
design community who gave their help, advice,
and, most importantly, samples of their work.

We would like to thank, in particular:
Mike C. Place at Build (London), Roger Fawcett-
Tang at Struktur (London), Stefan Sagmeister
at Sagmeister Inc. (New York), Paul Austin at
MadeThought (London), Richard Bull at Yacht
Associates (London), Alan Aboud at Aboud
Sodano (London), Clifford Hiscock at Williams
and Phoa (London), Patrick Morrissey and
Malin Wallen at Why Not Associates (London),
Bill Cahan and Gwendolyn Rogers at Cahan &
Associates (San Francisco), Sarah White at
Tolleson Design (San Francisco), Michael Bierut
at Pentagram Design (New York), Ryan Carson
and Ryan Shelton at BD4D (London), Hamish
Muir (London), David Jury at International
Society of Typographic Designers (London),
Marcus Hoggarth at Pogo (London), Alice
Twemlow at AIGA (New York), David Arkell at
The Colourhouse (London), Martin Hennessey
at the writer (London), Teal Triggs at Kingston
University (London), Bruno Maag at Dalton Maag
(London), James Warfield and Andrew Townsend
at WIG-01 (Sheffield), Kieran McGinley (London),
Ben Cotterill (London), and Jason Tozer (London).

Contents

Introduction

Detail from Levi's campaign
created by Aboud Sodano.

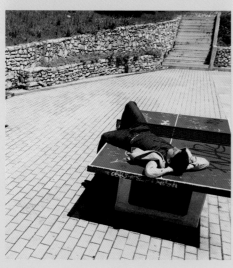

The design budget forms a singular and pivotal focal point for any creative endeavor. Whatever the creative expression, contained message, or target audience, the budget affects the fundamental levels of your design's delivery. The budget often holds a negative sway over how a designer begins to think about a project and, in turn, its production and end result. The tighter the budget, the more a designer's armory of physical interpretation is stripped away. Budget and cost can be powerful drivers in producing great work. The budget does not, however, need to override the main reason for creating or designing a project. An idea, vision, and creative expression are far more valuable assets for developing great design. Money generally helps, but it can often detract from the process of innovating, expressing, and imagining. Thinking purely about budget can prompt a designer to leap to the executable aspects of a project before thinking about the why and how. Remember—"budget" does not have to mean "cheap." The perceived value of a piece of communication or design is not directly related to its production cost. Yes, many great designs contain strange processes, untold levels of print, and sumptuous overdetailing, but at what cost? Execution alone is not a precursor to well-crafted work. You will find the raw elements of a successful design

This spread and next spread
Details from several projects
featured in Section Two.

under the skin of a project. These elements form the foundation for the design process: expression, innovation, originality, a clear message, well-articulated ideas, and finely crafted graphics. From these few essential ingredients, any level of project or design initiative is achievable and, more important, it will have lasting relevance. *Great Graphics on a Budget* explores the relationship between a designer's vision and the reality of creating that vision within fixed financial parameters. Often the two points are initially divergent, but with intelligent planning and creative freedom, they converge to create some of contemporary design's most compelling projects.

The book is divided into three areas. **Section One** is an overview of the design industry and the challenges that a designer faces. The text focuses on how those challenges can be embraced and used as an advantage in creating significant work. It is a fluid and transient time for the design community; technology, accessibility of knowledge, blurred discipline boundaries, and disparate creative styles create a buoyant environment in which to practice design. At opposing ends of the spectrum, the largest projects command new heights of revenue, while smaller and tighter creative exercises proliferate. Even a small two- or three-person team can

fluctuate between these two worlds during any given year. The skill is to stay true to the creative path and the execution of a vision, rather than be hampered by budgetary constraints.

Section One will also touch on the collaboration between client and designer and designer and printer, as well as on the effect of a wide range of supporting creative suppliers. This interaction is of particular interest as the periods of collaboration during a project often lead to the most unusual or compelling design solutions.

Section Two provides the main thrust of this book and details project case studies from over 40 individual designers, teams, and institutions. Selected from around the world, the designers are renowned for creating some of the best and most inventive contemporary work. Each was asked to select a project or projects that captured the challenge

THE KEY IS TO THINK LATERALLY, EMBRACE THE CONSTRAINTS, AND THINK POSITIVELY ABOUT THE PROJECT.

A+D

This is the call for entries for Directions 2001 - the 52nd annual awards event held by The Advertising & Design Club of Canada. We hope you'll enter your work for one very important reason: this is THE yearly event that especially recognizes the art in what we do as communicators. 'Artist' has become a renegade word in our business. A legion of flavor-of-the-month catchphrases have emerged to replace it, all designed to dance nicely to the tune of market research and win the approval of clients. So be it. But for most of us, it was the art that first inspired us and got us started. So in spite of it all, we still put art into everything

we do. And we don't apologize or seek legitimization for it. Because at the end of the day, what use is a great idea if it's not expressed artfully enough to evoke some kind of emotion? There's an art to visualizing a great idea and there's an art to writing a great headline. There's an art to laying out an editorial page, creating a logo, designing a web site, illustrating a concept, taking a great photograph or directing a film. And there's an art to imbuing commerce with creativity. The art in what we all do is important. Without the art, all the marketing in the world goes nowhere. All the ads, logos, web sites, photos and illustrations just won't touch people, let alone get noticed by them. So, please enter your work, for the sake of our art. To celebrate our art. And to WIN. What better affirmation could there be of the art in what we do? The deadline for entries is 5:00 pm, May 7, 2001.

HAVE AN IDEA—
GOOD IDEAS, CONTENT,
OR MESSAGES HAVE
GREATER IMPACT.

THE PERCEIVED VALUE
OF A PIECE OF
COMMUNICATION
OR DESIGN IS NOT
DIRECTLY RELATED TO
ITS PRODUCTION COST.

created by a restricted budget and to demonstrate how he or she succeeded and even used it to his or her advantage.

Of particular interest is how they tackled the various constraints presented to them and, in turn, how those constraints inspired a particular creative path. These challenges are explored along with the practical elements of how the projects were achieved. The contributors' insights provide an understanding of the less tangible elements of creating a design as well as specific hints and tips gathered from their experiences. Their skill and vision are the reason so many powerful creations were available for this book.

Section Three is a reference guide that features valuable information on resources, collaborators, suppliers, and contacts. Each of the contributors has also recommended suppliers who add their considerable skills to the challenge of creating excellent work in a financially restricted environment.

The creative individuals and teams in this book have one common characteristic—they don't settle for the mundane or expected. When challenged with a tight budget, they turn it to their advantage with an elegant snapshot of creative thinking. These designers are no strangers to thinking creatively about how to use their budgets effectively. Tight budgets are often a consistent element of the design process, and many designers relish the challenge. Rather than looking at the restrictions or limitations as a

negative, they view the challenges as a set of guiding parameters that shape their creative expression.

The featured contributors also have a high level of intelligence, passion, and rigor that they apply to their work, regardless of budget. The key is to think laterally, embrace the budget, and think positively about the project.

Viewing budgets as a constraint or a limit on the design process defeats the practice of creative thinking. Whatever the project, poor design is poor design, and it cannot be blamed on a lack of budget. A few extra production trimmings cannot replace good design and content. If tackled well and based on content, creative integrity, and passionate expression, the ultimate cost is irrelevant other than allowing for the most basic of materials to communicate the project.

Like any creative endeavor, the idea and the impact on an audience are the most important factors.

Section One
Design and the Budget

Detail from "Open"
by Eleethax.

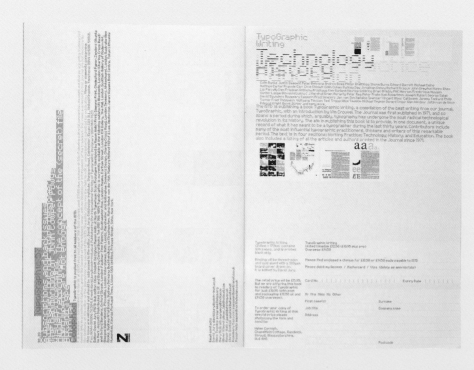

Left
"Typographic," a publication
by the International Society
of Typographic Designers,
commissions a different designer
for each issue. The restricted
budget is traded off against the
freedom the designer receives.

Below left
Although faced with limited
funds, GTF devoted a lot of time
to researching different processes
and materials resulting in some
ingenious discoveries.

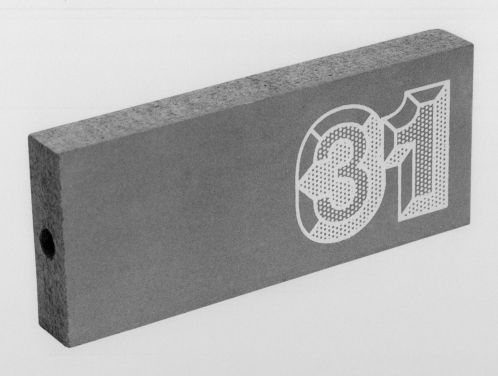

When a designer is commissioned for a project, among the first thoughts that run through his or her mind are: Will I be able to create the quality of design I want? Will I have enough time? What is the budget? If not the first thing a designer thinks about, the budget will be fairly high up on the list. From a pragmatic standpoint the budget can and does affect a commissioned project. Generally, designers care deeply about the designs they create and may worry about the budget affecting the quality and beauty of the design. There are, however, ways of looking at the budget and its effects that help answer the questions of time and quality of product.

Budget Doesn't Mean Cheap
Budgets tend to get a bad rap. Although they are commonplace in the design industry, the perception of working to a budget brings to mind restrictions and compromise. Tell a designer he or she has a specific budget and all the great things that might have flitted across their minds are, many times, replaced by thoughts of cheap production that devalues even the most sophisticated design. In actuality, whatever the level of financial outlay, every project has some form of budgetary restriction. The important questions to ask yourself are: why the project matters, whom it is for, and how it can best be creatively expressed.

The way to tackle the issue, or non-issue, of budgets is to forget what might have been and deal with the reality of what can be. The way forward is much clearer and easier if it is not viewed as a restriction. It can be easy to get caught up in the details early on, which can stifle creativity. In the initial stages of a project, designers conceptualize fresh, new ideas regardless of cost. The mental playground is much broader, allowing for richer, more expansive thinking. You will more than likely generate ideas that you may have dismissed had you applied all the perceived restrictions to your thought process. A second phase of brainstorming can then be used to apply some reality checks to the original ideas. At this stage you can think more specifically about the parameters of the project and how they can be refined to fit a particular budget. In contrast, some designers thrive on the challenge that a restricted budget provides and use it as the driving force for their ideas. It becomes a catalyst that fuels not only their choice of materials and production techniques but also their concepts. Either of these approaches can help you avoid seeing the budget as a compromise that threatens the quality of your design. Lecturer and design theorist Teal Triggs expands on these themes in her essay later in the book.

SOME DESIGNERS THRIVE ON THE CHALLENGE THAT A RESTRICTED BUDGET PROVIDES AND USE IT AS THE DRIVING FORCE FOR THEIR IDEAS.

It Is Not All One Color

Contrary to popular opinion, tight budgets don't have to mean a single-sided, one-color leaflet. The reality of their effect is more deep-rooted. The budget affects several key things: commission fees, timings, media, distribution, production costs, and final delivery. A balance of these areas can create space for a designer to operate where it would seem to be financially impossible at first glance. The initial design fee is only the stepping-off point.

Time is a key resource for a lower-budget project. Many of the most single-minded designers and design teams use their personal time and resources to bolster the assignment. That is not to devalue their work or services, but it stems from being pragmatic as well as passionate about the project. Extra time afforded to a creative challenge will definitely create stronger work. Designers can use their conceptual skills to seek new avenues of attack if they spend longer wrestling with the problem.

On a more emotional level, passion is a strong motivating factor for designers when it comes to working on projects with restricted budgets. The project becomes a labor of love, eliminating any feelings of compromise and generally resulting in designers applying much more of their time and effort in solving the challenges that limited funds can create. These projects often involve collaboration or an individual and personal effort, such as taking the photography themselves or coming in on weekends, when other resources are not available. The rewards then go beyond the financial and become a personal form of expression and, ultimately, satisfaction in creating something aesthetically or conceptually beautiful. Many designers would say that this level of integrity is devoted to all of their projects, but the projects with a restricted budget seem to require just that bit extra.

In contrast and on a more technical level, you can view the project in sections to avoid losing money that would otherwise pay for a designer's services. Profit margins on print handling can be compromised if the fees assigned to the actual design are profitable enough. Shaving unit costs by reducing an item's paper weight can free otherwise wasted funds to produce higher quality print. Freeing up resources by allowing a supplier more time can provide the opportunity to reduce production costs.

PASSION IS A STRONG MOTIVATING FACTOR FOR DESIGNERS WHEN IT COMES TO WORKING ON PROJECTS WITH RESTRICTED BUDGETS.

Research Pays Off

Research can be key to finding ways of making the budget go further. Discovering a cost-effective process or material can have a dramatic and pivotal effect on the design solution. An impasse suddenly dissolves, offering new and exciting opportunities to develop. Solutions can be found almost anywhere, and your research should not be limited to the typical avenues, such as books, magazines, printers, and finishers. A limitless supply of everyday products and materials are waiting to be used in new and unusual ways by designers willing to look for them. Often these products and materials are made in such vast quantities that their unit cost is significantly reduced. Even if they are not, then the resources that make them are already in place, saving you the time and money of having a printer or finisher emulate the effect or process. A number of case studies within this book demonstrate this to great effect. For example, in "Meetup," EGO ingeniously used the easily recognized and readily available blank name stickers as part of the identity for a company that brings people together. Although many traditional logos and icons were developed and considered, the discovery of this everyday and easily overlooked product has created a clever and memorable piece of design. It goes without saying that whatever you discover and consider using should be relevant to and driven by your original concept. However, the design process is fluid and organic, and at times your ideas can be influenced by the materials and processes you discover. There is nothing wrong with that as long as there is an aesthetic and conceptual relevance to the project and its aims, as in the case of the "Meetup" identity. It can be all too easy to be swept away by unusual and novel processes and lose sight of the function of what you are creating. A certain amount of restraint should be maintained, and if something you find can't be used this time, keep it—you may have a future project that it is perfect for. Many designers and design practices have seen the great benefit of research and have developed libraries of unusual and everyday things. One company in particular, Artomatic, a London-based screen printer, is so frequently asked by designers to source new materials, that they now search the corners of the world for new materials, processes, and products. Their ever-increasing library of resources has become a well-used and invaluable place for designers to browse and be creatively inspired.

Above
The design team GTF created this paperback book as an exhibition guide after discovering that it was far more cost effective to produce than their original idea of a broadsheet poster.

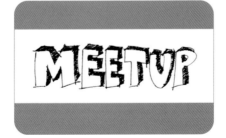

Above
EGO has taken an everyday and inexpensive found object and reinterpreted it to create a new corporate identity.

BY WORKING WITH THE
SKILLS AND RESOURCES
OF ANOTHER CREATIVE
TEAM, YOU CAN ACHIEVE
A PROJECT WITH AN
ENHANCED RESULT.

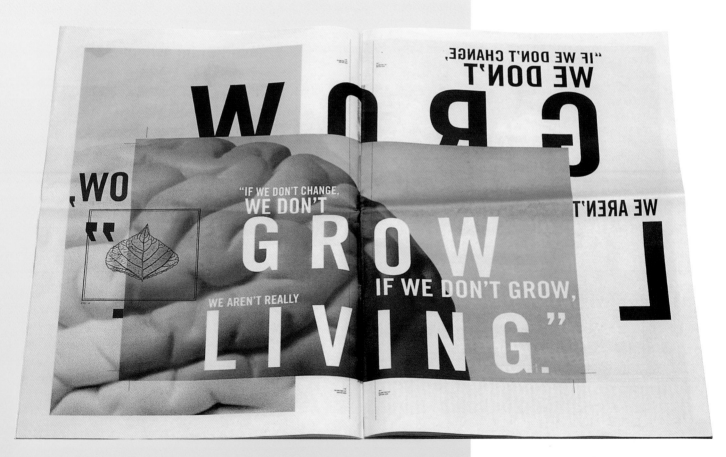

Above and right
Details from a collaborative
project called "Open,"
created by a collaborative
community of designers in
the United States.

Collaboration

Collaboration with other creative minds can stretch even the most meager of budgets to new places. Printers, photographers, writers, and associated designer industries wrestle with the same working realities as designers, when striving for new and interesting ways to express themselves. By working with the skills and resources of another creative team, you can achieve a project with an enhanced result. Funds applied to a piece of intriguing and stimulating writing can stretch much further, and the work can be designed in many more creative ways than by relying on a single print technique to express the same message. Images can speak with the same power—a single illustration or photograph can articulate with great impact if applied in the correct context. However, as with research, collaboration should not be limited to working with those in the graphic design industry. Often the most exciting and stimulating collaborations occur when you cross the boundaries into entirely different industries, such as technology, automotive, and architecture. These collaborations can come about through research for a particular project. For example, a process or material from one industry might lead to an entirely innovative and new way of thinking about a project. This could, in turn, lead to such collaborations as designer and technician or designer and architect. This process can be a catalyst for reaching clever and cost-effective solutions.

Working in a collaborative environment brings spontaneity and reaction into play. The process of discussion broadens the interplay of ideas and ways of working. The solution to budget restrictions can be found in both the most unusual and mundane places. A fresh perspective or opinion can circumnavigate a designer's view of a project. It sparks new attitudes and places to investigate. The choices and paths are easier to explore once the designer has choices. Collaboration avoids too myopic a view of the problem. Isolation can create the most eclectic and powerful design, but, as a working practice, it is harder and much more reliant on the designer's moment of inspiration. Often a simple jump start or well-asked question can open a direction the designer has yet to consider. It also keeps the process moving, and any creative impasse encountered is easier to release with idea sharing.

A FRESH PERSPECTIVE OR OPINION CAN CIRCUMNAVIGATE A DESIGNER'S VIEW OF A PROJECT. IT SPARKS NEW ATTITUDES AND PLACES TO INVESTIGATE.

NEW AVENUES OF DISTRIBUTION, COMMUNICATION, AND ENTERTAINMENT HAVE ALLOWED DESIGNERS TO DESIGN IN AN ENVIRONMENT THAT IS MUCH LESS HAMPERED BY BUDGET CONSTRAINTS THAN IN TRADITIONAL MEDIA.

Technology

The introduction and continuing proliferation of technology and the access to this technology have made creating with lean resources palatable. Digital media has released many designers from the shackles of physical production techniques. They can create, edit, and perform to highly sophisticated levels and share with a global audience instantly without ever leaving the digital space of their computers. New avenues of distribution, communication, and entertainment have allowed designers to design in an environment that is much less hampered by budget constraints than in traditional media. The result is a continually expanding creative space with freedom to roam.

The same technology has drastically reduced the cost and technical difficulty of creating both print and motion work. Designers have been handed tools they can operate from a laptop that release them to design without huge teams of technical support, equipment recourses, and difficult production schedules. As the designers embrace these production techniques, they become more able to create a film, TV commercial, or book project that would have been beyond their means without the software and hardware they now own. They gain a

freedom of movement and license to create on their own terms. The creative decision-making and path to the end result open up to them.

These designers still share the experience with camera operators, printers, illustrators, or writers, but if times are lean they can grab a digital camera, shoot the image, download it, and begin designing within minutes.

This proliferation of technology is balanced with a return to more artistic and traditional skills; Polaroids, paint, models, and a huge range of unexpected media can be blended into a cohesive mix with a few simple digital techniques. So, rather than viewing the technology as cold or dry in its execution, it becomes a way to create across a broader palette.

Blurring the Boundaries

Boundaries are in a state of flux with designers increasingly moving in and out of different creative disciplines. This movement is a symptom of a designer's hunger to create in different ways, coupled with the accessibility to technology and new skill sets. Designers are much more confident about their ability to cross these boundaries. Clients and companies are also more comfortable about taking

Right
GTF crosses from one area of design to another. This project encompasses exhibition and environment design.

designers on their creative merit and allowing them to either specialize or wander into new areas of expertise. Creatively, designers can draw on skills and approaches learned from one discipline and use them in another. This problem solving and openness to learn and adapt are extremely useful tools when you are faced with limited resources. They also pick up creative license, which opens the designers to trying a solution outside the perceived norm within a discipline. For example, print has a tangibility that interactive does not, but looking at the rhythm of navigating an information system may promote a designer to look at pagination, size, and format in a new way. Should all the pages be the same size or weight? Can the image appear in different ways? What materials strengthen the message? The designer can use this depth of experience to help clients see alternative solutions. If a designer is comfortable working with a variety of disciplines, then he or she also has the opportunity to suggest a new approach or a different way of communicating. This flexibilty provides another way to take control of the parameters of the project and find room to develop a far more creative and appropriate solution.

PROBLEM SOLVING AND OPENNESS TO LEARN AND ADAPT ARE EXTREMELY USEFUL TOOLS WHEN YOU ARE FACED WITH LIMITED RESOURCES.

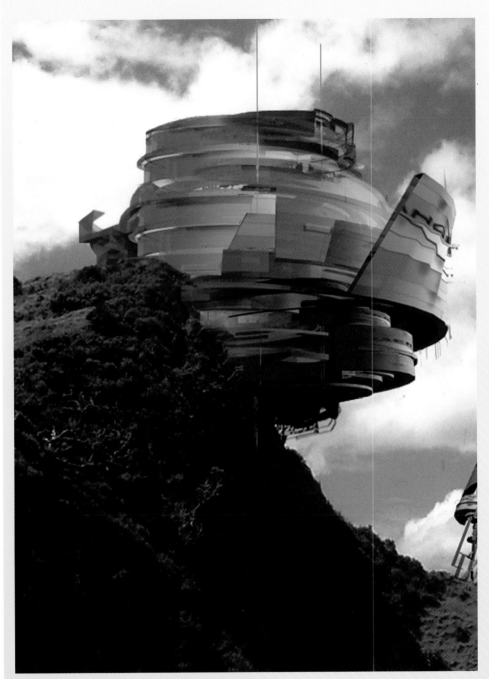

Above
Web designers have seized the cost-effective opportunities that Internet technology provides and harnessed its ability to share work and ideas with people the world over, as illustrated in this detail from experimental work by onemorethantwo.

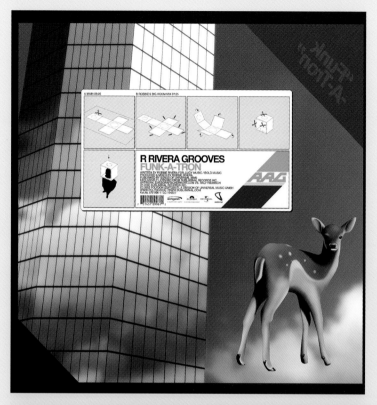

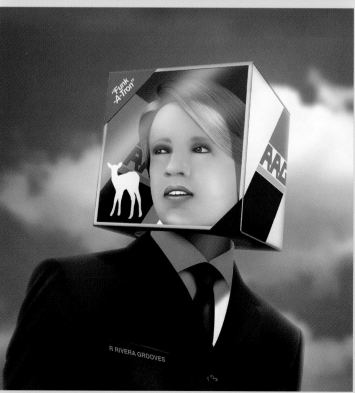

Client Dialog

The client or the commissioner of a project can often be the object of derision if a project's budget is restrictive. However, it is more commonplace for the allocation of funds to be dictated by many layers of decision making rather than by any one individual. The simplest truth is usually a company's profit margin. The cheaper the production, the less is scraped from the bottom line. Upper management may not truly grasp the tangible benefit of design and its production processes. Dialogue and communication can help, but if contact with the decision maker who holds the purse strings is not forthcoming, it typically falls on deaf ears. Lack of communication is a relatively frequent situation but probably not the main reason a project is given a leaner or insufficient budget. The reasons could be as varied as a lack of understanding of the scope of the project, underresourced departments, delays in allocation of funds, overuse of funds elsewhere, lack of funding for charitable or artistic institutions, or economies of scale. Additionally, smaller businesses inevitably have significantly less to play with than their larger counterparts. A lean budget does not need to affect the overall impact and process of creating and managing the

Left above and below
Eike Grafischer Hort archives all of their work and use it as inspiration for new pieces, as well as for helping them find out what their clients are looking for. In this case, a design that was originally intended for one client proved to be better suited to another.

Right
MadeThought developed an innovative binding method for a new trend-forecast book commissioned by textile designer Laura Miles.

project, especially if the designer and client have a clear understanding and rapport. Having each party know the expectations of the other generates opportunities for both sides to increase the potential of a project. Sharing the scope of ideas with the client and discussing the logistics early benefits both parties.

There may be times when the project you are creating is the right solution but is in need of increased funds to make it work effectively. On these occasions, if the client has been involved in the creative process from the start, early collaboration helps them understand the benefit to the project of increasing their financial investment. Diti Katona of Concrete raised a similar point:

"Generally, even though [some of our] projects may have been executed on limited budgets, it is not the budget that drives the approach to the project. If we strongly believe that more money is required to do something effectively, we try to convince our clients that the investment is worth it. But in many cases, spending more money will not make a project better. A good idea simply executed is the most effective way of communicating."

Because designers function best in an atmosphere of trust and creative freedom, they should explain their inherent understanding of quality, communication, and visual expression to the client. Building trust by seeing through and around a client's problems and, in particular, tackling a meager budget with a considered approach can challenge and surprise the client. A clear understanding of the product or message and a strong continued dialogue with the client builds lasting, creative executions. Openness in this dialogue is key; the more articulate and informed the designer is, the more likely a client will be open to innovation – creating the opportunity for a compelling result.

HAVING EACH PARTY KNOW THE EXPECTATIONS OF THE OTHER GENERATES OPPORTUNITIES FOR BOTH SIDES TO INCREASE THE POTENTIAL OF A PROJECT.

THE SIMPLER THE
PROJECTS AND THEIR
DELIVERY, THE MORE
IMPORTANT THE QUALITY
BECOMES. WITH LITTLE
SPACE TO HIDE, A
DESIGNER'S WORK LIVES
AND BREATHES THROUGH
THE QUALITY OF ITS
PRINT AND PRODUCTION.

Printers and Paper Companies

Printers are often more pivotal to the successful completion of a tight project than they are given credit for. Although a pragmatic and organized industry, the best exponents of printing apply the same level of creative thinking to a project as designers do. So, rather than it becoming purely a numbers game, the printer can inspire and stimulate debate and ideas. This relationship becomes one of the most valuable resources to a designer in stringent circumstances.

The simpler the projects and their delivery, the more important the quality becomes. With little space to hide, a designer's work lives and breathes through the quality of its print and production. The subtle and intangible nature of quality, perfection, fit, and purity of color are all the more apparent when a printed piece is simpler in execution. For single-color print to have the aesthetic quality of more complex printing, it relies more fully on the sheer quality of print. There are few areas of latitude.

The perception of quality is ultimately affected by the excellence of the paper

stock. Whatever the level of the printing process and size of the printing press, if the stock is not up to the job, everything else suffers. It is often better to forgo extra colors or extra finishes to have a better quality substrate. Its touch, feel, and ability to hold print will drastically improve the sense of worth for a design.

Being clever with the finishing provides designers with areas where they can save precious money. Hand-finishing or fulfillment of elements means that parts of the project can be labor intensive, but manageable costwise, especially if they decide to do it themselves. Roger Fawcett-Tang of Struktur reduced the cost of producing a 48-page self-promotional book by hand-finishing all 1,000 copies himself. Although time consuming, he was able to maintain his own high level of quality control, and each book in itself has more worth because of it.

David Arkell of The Colourhouse in London takes us through an example of this relationship in his essay later in the book.

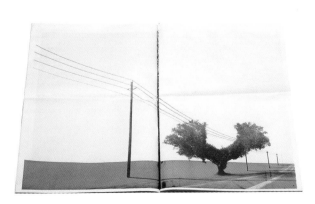

Right top and bottom
Working closely with the printer, design practice Struktur developed a clever binding method by using an elastic band rather than traditional staples, which were proving too costly.

The choice of paper stock was also discussed with the paper company to help the designer maintain a high quality while meeting the demands of a small budget.

Left
Details from "Open," a collaborative project by Eleethax.

DON'T BELIEVE YOUR
OWN HYPE

HAVE A GOAL (OR MANY)

TRY SOME THINGS WITH
NO END RESULT

BE AWARE

TALK TO OTHER
DESIGNERS

TALK TO PEOPLE OTHER
THAN DESIGNERS

MAKE MISTAKES

DON'T USE TECHNOLOGY
AS AN EXCUSE

KEEP LEARNING

BE TRUE TO WHAT
YOU BELIEVE IN

BE HUMBLE

WORK HARD

DON'T THINK ABOUT IT—
DO IT

DON'T TALK ABOUT IT—
DO IT

TEACH

BE SELFISH

SHARE

HAVE FUN

Creative Thinking
Here are a few ideas and ways of working that can be applied to any project to inspire creative thinking:

FORGET EVERYTHING
YOU KNOW AND
START AGAIN

EVEN THE BIGGER
HITTERS IN THE
CREATIVE INDUSTRY
TACKLE LOWER-BUDGET
PROJECTS FOR THE
ABILITY TO FLEX THEIR
CREATIVE MUSCLES

Creative Freedom

Many designers take on lower-paid projects precisely because they can achieve a creative goal that a higher budget would not allow. The economies of scale that come with large marketing budgets can mean there is less opportunity for designers to express their talents. Smaller budgets can bring more trust of the designer and a creative freedom that will allow a new or interesting approach. Even the bigger hitters in the creative industry tackle lower-budget projects for the ability to flex their creative muscles. The ideas are pivotal to any design project but become all the more apparent when dealing with a budget constraint. Innovation and compelling content are fundamental to the success and relevance of any design assignment. Designers' ideas can transcend even the most meager of budgets. Emotion, inspiration, and intellectual strength will survive even the lowest form of delivery. Martin Hennessey touches upon communicating with relevance in his essay, "The Three Rules for Great Copy," later in the book. One of the common themes in each of the following case studies is the designers' lack of regard for the budget. This does not mean they design in a vacuum or are unrealistic about the practical restraints it can have.

They are focused on process and outcome. The projects range across print, digital media, advertising, and products. Despite the range of disciplines and wide range of locations of the designers, the same outlook reappears. We all work with budgets every day. Why is any particular project special? Yes, they have a few less dollars per item or they can't double-emboss and foil the cover. The effect is that many of the trivial and overwrought parts of the design process are cast aside. It is the level of intelligence and aesthetic beauty designers craft that comes to the fore. They talk to others, isolate themselves, are elated, or get depressed, but the outcome is a consistent drive for quality —a quality based on craft, skill, and intellectual judgment. They don't deliver trinkets or shining baubles but a level of design that will have relevance beyond budgets, the designers' desks, or appearing in this book.

dixonbaxi would like to thank all of the designers and the teams they work with.

DESIGNERS' IDEAS
CAN TRANSCEND EVEN
THE MOST MEAGER OF
BUDGETS. EMOTION,
INSPIRATION, AND
INTELLECTUAL
STRENGTH CAN
SURVIVE EVEN THE
LOWEST FORM OF
PRODUCTION DELIVERY.

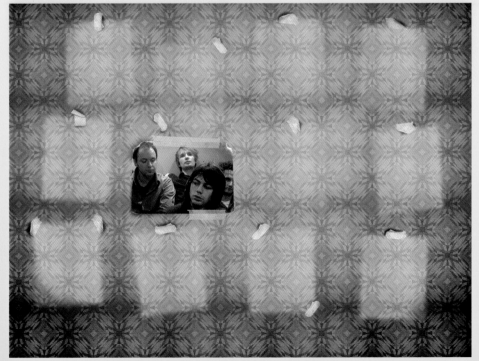

Above and left
Simple and clever ideas
are always memorable,
regardless of budget.

Section Two
Projects and Essays

Detail from The Steamship Mutual
Annual Report and Accounts 2002
by Williams and Phoa.

The Steamship Mutual Trust

Project
The Art of Engineering
and The Art of Sculpture

Client
Benson Sedgwick Engineering

Design
Darren Hughs, David Jury,
Kelvyn Smith

Printing
Letterpress:
Kelvyn Smith

Offset lithography:
Simmons Print

Print Run
500

Specifications
11" x 14.5"
28 cm x 36.5 cm
24 pages

Colors
Black plus one

Materials
Text: Zerkall 175 gsm

Cover: Zerkall 350 gsm
(smooth) with matte laminate

Binding
Spiral bound

Right and opposite
The covers form alternate
introductions to the project,
allowing the reader to explore
the two convergent themes from
opposing covers by rotating the
book. The subsequent pages are
cropped to form slim panels of
alternating text and image pages.

The photographic material
was printed by offset litho in
a mixture of black and duotone.
The accompanying text was
printed by letterpress, scanned,
and then printed by offset litho.
The well-balanced layout creates
a feeling of craft with a clear and
direct typographic structure.

Benson Sedgwick
Engineering, based in North
London, specializes in unusual
precision engineering projects
and has built a reputation for
its collaboration with artists
in the design and construction
of large-scale public sculptures.
The company needed a
promotional document that
was capable of appealing to
two contrasting client bases:
artists and engineers. In
addition, they only needed
500 copies.

The creative solution was
to reduce the size and shape
of each page. Turning the
pages of the document was
like walking around a three-
dimensional object—no matter
what page you were looking
at, you could glimpse part of
what you had previously seen
and also see something of what
was to come. Like a sculpture,
it could be approached from
either direction—one cover
offered "The Art of Sculpture"
and the other "The Art of
Engineering." The two
subjects then met at the
center of the brochure.

To reflect the precision
and physical presence of
engineering, the designers
proposed a large format
(11" x 14.5"; 28 cm x 36.5 cm)
and the use of letterpress
printing technology. This
method of production was
made all the more viable
because of the short print run
and, in fact, became a key
factor in ensuring that they
were able to keep within a
tight budget due to the reduced
unit cost of the printing.
Because the designers were
managing the printing as
well as the designing of the
brochure, they were able to
control every detail, including
minor adjustments affecting
position and depth of color
being made on the press.
Letterpress can be a slow
process, especially in this
case—the brochure was
printed entirely by hand on a
proofing press—but the result
has the contemplative qualities
of longevity and stillness, as
well as a unique appearance
and physical presence. These
characteristics, integral to
letterpress, were considered
appropriate to the subject.

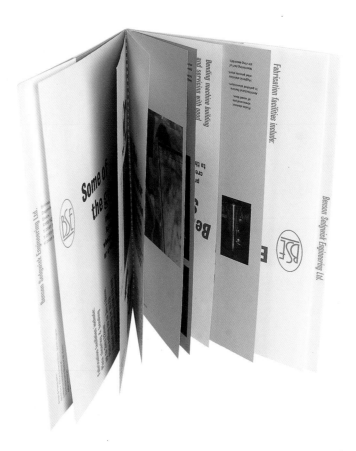

the
art of
Sculpture

BSE

the
art of
Engineering

BSE

Project
Dietheater Konzerthaus
promotional literature
and products

Client
Dietheater Wien

Design
Günther Eder

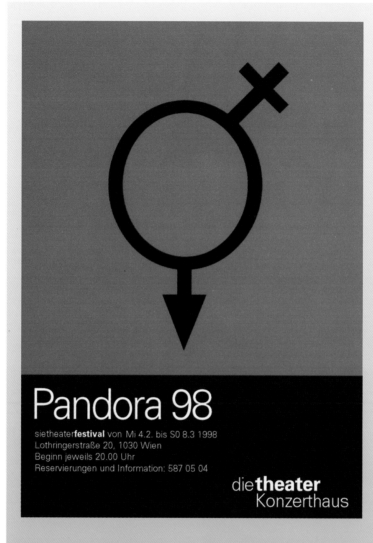

Left
To develop consistency
and a clear identity for the
festival, loose-sheet flyers
were distributed across the
city. The simple and bold
use of two colors created
an immediately recognizable
design theme.

Opposite top
Pandora 1998:
Pills (placebos) promoting a
temporary and reversible
gender transformation were
handed out with the festival
program. This simple, low-cost
item echoed the performance
aspects of the theater group
and involved the audience
from the moment they
encountered the promotion.

Opposite bottom left
Pandora 2000: Focusing on
"Women's art from the
countries of post
communism," the emblem
of communism is transformed
into lipstick and sickle. Using
an existing graphic symbol and
presenting it in a new light, the
designers quickly built a strong
message. The highlight was a
set of giveaway lipsticks
bearing the Pandora logo.

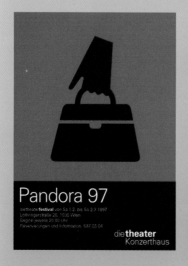

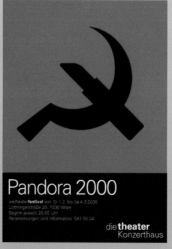

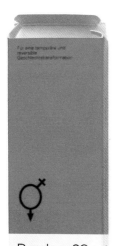

Pandora 98
20mg · Filmtabletten

M Æ F / F Æ M

Wirkungsweise:
PANDORA 98 gehört zur Gruppe der radikalen Chromosomen-Wechsler. Die Filmtabletten ermöglichen eine kurzfristige Umwandlung der Geschlechter, indem die Chromosomen-Paare von weiblich und männlich bestimmten Zellen auf kurze Zeit vertauscht werden. PANDORA 98 wirkt zusätzlich auf die Funktion der Hormondrüsen, womit eine begleitende Änderung des psychischen Verhaltens ermöglicht und die subjektive Wahrnehmungserfahrung des jeweils anderen Geschlechts simuliert wird. PANDORA 98 ist als Frau- oder als Mann-Präparat anwendbar. Die Wirkung ist ca. drei Stunden nach Einnahme autoreversibel.

Arzneiform:
Filmtabletten. Oral einzunehmen.

Zusammensetzung:
Eine Filmtablette enthält 98mg SWOP (wirksamer Bestandteil). Sonstige Bestandteile: Staubzucker, Plasdone K25, Magnesiumstearat, Pfefferminzöl, Cabosil.

Anwendungsgebiete:
Bei geschlechtstypischem Rollenverhalten verschiedenster Ursache. PANDORA 98 kann auch über einen längeren Zeitraum zur Rückfallverhütung bzw. Phasenvorbeugung angewandt werden.

Primäre Anwendungsgebiete sind:
· Auflösung von stereotypischen Wahrnehmungsmustern.
· Erweiterung des geschlechtsspezifischen Erfahrungshorizontes.
· Zur Begleitung von langfristigen Geschlechtsumwandlungen.

Vorsichtsmaßnahmen für die Verwendung und besondere Warnhinweise:
Schon geringe Einnahmemengen von PANDORA 98 sind höchst wirksam. Typisch weibliche bzw. männliche Wahrnehmungsmuster sind bereits unmittelbar nach der Einnahme erfahrbar. Bei gleichzeitiger Einnahme von Alkohol kann sich die Wirkung weiters verstärken. PANDORA 98 ist mit Vorsicht zu genießen bei Zwitterverhalten, multiplen Persönlichkeiten sowie bei allen Formen von hormonellen Störungen der Schilddrüse. Symptome einer Überdosierung sind bei Männern wie bei Frauen Zittern, trockener Mund sowie eine Steigerung der Kommunikationsbereitschaft.

Wechselwirkungen:
Besonders gute Wahrnehmungsveränderungen sind in Verbindung mit der Rezeption des derzeit stattfindenden PANDORA-

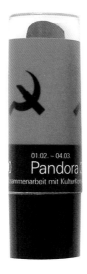

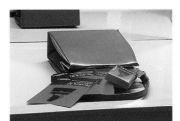

Above
Pandora 1997: Secondhand handbags were placed in women's restrooms. The bags were collected from thrift stores and adapted to the project by filling them with the event's literature—they contained a program and a package of tissues. This striking and fun application of found materials created a high impact via word of mouth and the unusual surroundings.

Dietheater Konzerthaus is a Vienna-based theater group that produces annual alternative festivals. One of their leading festivals is Pandora, which is dedicated to women's theater and performance. It allows artists to use the festival's large sideshow as well as their own fantasy, intelligence, and artistic ability to exhibit their performing potential.

To achieve a unique and effective campaign, the designers looked for possibilities beyond the usual promotional flyer and poster. Realizing the restraints of the budget, they created a range of promotional items that were inspired by women. The design used a bold and graphic tone with bright colors and clear graphics to make the most of a limited color palette.

Improvisation and looking beyond the usual techniques created more possibilities than first appeared available. Found objects, readily available products, and a well-structured print system meant the designers could broaden their creative goals while being realistic to the financial limitations of a cooperative theater group. They created a series of vignettes that intrigued and stimulated the potential audience while reflecting the theme of "Women."

Each year, the designers tackled the task with a new approach to the design and created additional giveaway items to amplify traditional marketing techniques.

Project
Graphic Design
Program promotion

Client
Yale University School
of Architecture

Design
Michael Bierut

The initial inspiration for this project was the desire of the new dean at Yale University, Robert A. M. Stern, to confound predictions that he would be propagating a doctrinaire historicist approach to architectural education. In working the problem out, the design team was also inspired by the work of the artist Lawrence Weiner, although the finished work eventually progressed to a distinctly new direction. The designers appreciated Weiner's use of black-and-white typography in rectangles, which the Yale project also uses. However, they found Weiner's use of scale very undesigned, in a good way: blunt and awkward. They tried to bring in a little of that sense of awkwardness, particularly at the outset of the project.

From the outset, the budget was determined by the use of the university's on-campus printing service and was non-negotiable. On the other hand, the design team made no attempt to limit the visual ideas. It reduced the production process to its most basic level using stark, singular printing and a robust, readily available stock.

The implied limitations actually developed the creative process into a more interesting place than the designers imagined.

The designers made a conscious decision to use only one color and an infinite number of typefaces, color being more costly and the use of typefaces being more or less free. Black was chosen as the color that the printer could most reliably reproduce and would have the most long-term durability.

The design interpretation became a visually eclectic mix of typographic exercises based around an underlying grid and set of layout principles. It allowed the design to be fluid and interpretive in its execution and build an ever-increasing dialogue from the initial iterations. The use of pure black and white increased the power of the design development. The text, content, images, and graphic elements were handled with a bold confidence and freedom of approach that harnessed different designer interpretations and allowed for spontaneity during the production.

Started in the autumn of 1998, it took only a few weeks to establish the overall design approach. From a simple recipe of paper, black ink, and type, the project has developed into a powerful and interpretive design process that continues today.

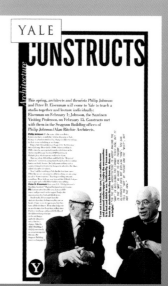

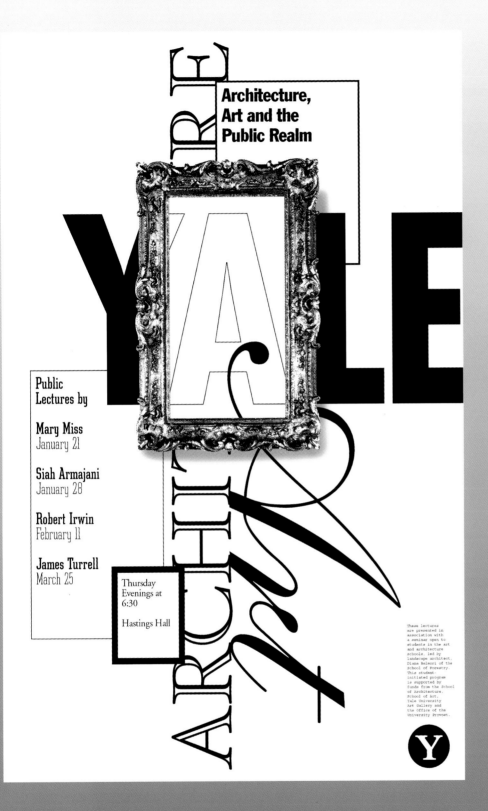

Architecture, Art and the Public Realm

YALE

Public Lectures by

Mary Miss
January 21

Siah Armajani
January 28

Robert Irwin
February 11

James Turrell
March 25

Thursday
Evenings at
6:30

Hastings Hall

These lectures
are presented in
association with
a seminar open to
students in the art
and architecture
schools, led by
landscape architect,
Diana Balmori of the
School of Forestry.
This student-
initiated program
is supported by
funds from the School
of Architecture,
School of Art,
Yale University
Art Gallery and
the Office of the
University Provost.

This page and opposite
An apparently chaotic
approach to typography is
underpinned by a rigorous
grid and layout structure.
It allows the designer to be
playful and expressive with
the text while building on the
continually developing identity
system. The overlapping
themes and graphic elements
create a dimensional quality
that resonates with
architectural principles.

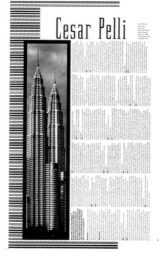

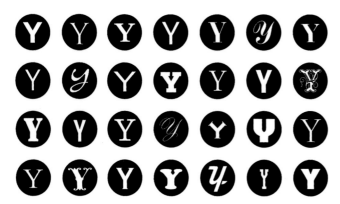

This page
The identity for the school uses the principle of an ever-changing logotype where each application can take a different typographic approach. Despite this chameleon-like approach, the identity builds in recognition as the bold combination of a reversed Y with the black circle becomes a distinct visual motif.

Opposite
This poster demonstrates the robust nature of design system. The simple rules provide a great deal of flexibility while creating a strong visual identity.

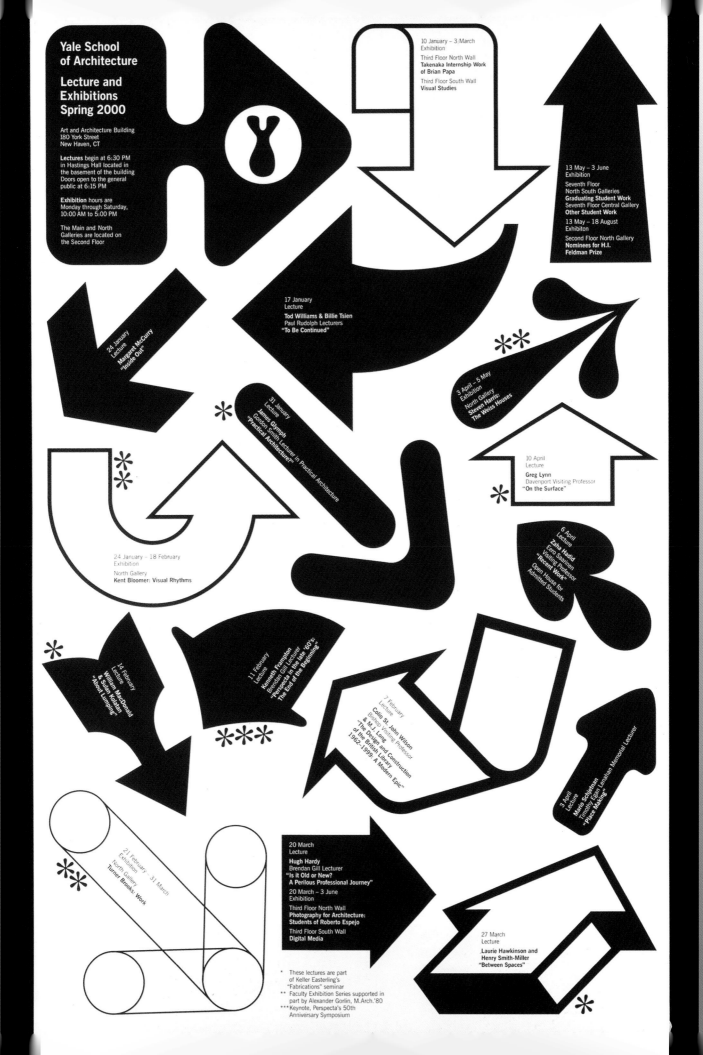

Yale School
of Architecture

Lecture and
Exhibitions
Spring 2000

Art and Architecture Building
180 York Street
New Haven, CT

Lectures begin at 6:30 PM
in Hastings Hall located in
the basement of the building
Doors open to the general
public at 6:15 PM

Exhibition hours are
Monday through Saturday,
10:00 AM to 5:00 PM

The Main and North
Galleries are located on
the Second Floor

10 January – 3 March
Exhibition

Third Floor North Wall
**Takenaka Internship Work
of Brian Papa**

Third Floor South Wall
Visual Studies

13 May – 3 June
Exhibition

Seventh Floor
North South Galleries
Graduating Student Work
Seventh Floor Central Gallery
Other Student Work

13 May – 18 August
Exhibiton

Second Floor North Gallery
**Nominees for H.I.
Feldman Prize**

17 January
Lecture

Tod Williams & Billie Tsien
Paul Rudolph Lecturers
"To Be Continued"

24 January
Lecture
Margaret McCurry
"Inside Out"

3 April – 5 May
Exhibition
North Gallery
**Steven Harris:
The Weiss Houses**

31 January
Lecture
James Ghmgh
Gordon Smith Lecturer in Practical Architecture
"Practical Architecture?"

10 April
Lecture

Greg Lynn
Davenport Visiting Professor
"On the Surface"

6 April
Lecture
Zaha Hadid
Eero Saarinen
Visiting Professor
"Recent Work"
Open House for
Admitted Students

24 January – 18 February
Exhibition

North Gallery
Kent Bloomer: Visual Rhythms

14 February
Lecture
**William MacDonald
& Sulan Kolatan**
"About Lumping"

11 February
Lecture
Kenneth Frampton
Brendan Gill Lecturer
**"Perspecta in the late '60's:
The End of the Beginning"**

7 February
Lecture
Colin St. John Wilson
Bishop Visiting Professor
& M.J. Long
**"The Design and Construction
of the British Library
1962–1999: A Modern Epic"**

3 April
Lecture
Mario Schjetnan
Timothy Egan Lenahan Memorial Lecturer
"Place Making"

21 February – 31 March
Exhibiton
North Gallery
Turner Brooks: Work

20 March
Lecture

Hugh Hardy
Brendan Gill Lecturer
**"Is it Old or New?
A Perilous Professional Journey"**

20 March – 3 June
Exhibition

Third Floor North Wall
**Photography for Architecture:
Students of Roberto Espejo**

Third Floor South Wall
Digital Media

27 March
Lecture

**Laurie Hawkinson and
Henry Smith-Miller**
"Between Spaces"

* These lectures are part
of Keller Easterling's
"Fabrications" seminar
** Faculty Exhibition Series supported in
part by Alexander Gorlin, M.Arch.'80
*** Keynote, Perspecta's 50th
Anniversary Symposium

The Budget Design Look
by Alice Twemlow, editor and program advisor at AIGA (American Institute of Graphic Arts)

The disastrous economy, compounded by the attacks on the World Trade Center in 2001, engendered a conservative mood in American society and business that, in turn, had an impact on the design community. Marketing and promotion budgets were slashed as companies downsized. Design studios lost clients, and many were forced to close. This was the context in 2002 for a corpus of work that felt more subdued and budget-conscious than the freewheeling excesses of the turn-of-the-century years when three hits of black with a gloss varnish, elaborate die-cutting, and exorbitant photography shoots were par for the course. The shift in tone was palpable. Suddenly everyone wanted to appear sensitive to the new political and social circumstances. In this context, lavish production values seemed distasteful somehow. And so, some of this year's design production, in its haste to be politically correct, may have bought into a low-budget "look" at the expense of cost-efficiency. Paper companies—ever quick to respond to the fickle shifts in taste of their designer-customer base—were early on the scene with papers to suit the utilitarian aesthetic. French Paper Company, for example, has a paper line that features "industrial-grade" papers such as Butcher (designed to simulate the waxed paper butchers use to wrap meat), Newsprint, Aged or Extra White, Packing (which comes in Brown Wrap, a "printable version of the brown paper bag"), and

Gray Liner ("with the look of shirt cardboard")—perfect for achieving an aura of budget-consciousness without actually having to get your hands dirty.

This is not to say that there were no examples of responsible, considered, and sophisticated design on a restricted budget this year—on the contrary.

An emphasis on well-intended restraint and simplicity is evident in many of the entries submitted to AIGA's annual design competition. "Compared with last year, we're seeing smaller formats, less foil stamping, and less extravagant production," notes Lana Rigsby, one of the competition's jurors. "Overall the entries seem to be very conservative. A lot of pieces are about how to respond to a small photography budget or the need to do a 10K wrap." The downside to this is that, with glitzy production values stripped away, conceptual weaknesses become all the more obvious. With limited resources there is more pressure on the talent and inventiveness of the designer.

The various solutions to this challenge include using illustration instead of costlier photography, investing more thought and means into the editorial aspects of a piece to increase the impact of ideas and content, and minimizing printing costs through careful planning. Among the winners in the Corporate Communications

Design section of the competition, two annual reports employed a similar cost-cutting device. Cahan and Associates's Silicon Valley Bank Annual Report 2001 and VSA Partners's IBM Annual Report 2001 ran the letter to the stockholders on the cover, thus saving space—after all, an annual report does not have to sell itself with a cover. Cahan & Associates explained the rationale: "Our goal was to keep the book simple, clean, direct, and forthright to reflect the bank's leadership style in these difficult times."

Another project that made a virtue of its shoestring budget was a small exhibition catalog by Efrat Rafaeli Design printed in two colors on cheap card stock and contained unbound in a plastic zip bag. "If this was from Europe, it would come out of East Germany," said juror Erik Spiekermann. "Everything is considered. It combines Letraset starbursts with desktop publishing themes."

And because budget was an issue for an admission publication for a Pennsylvania Quaker boarding school, Rutka Weadock Design divided the content into two halves. The first book, which contained the images, was printed in a three-year quantity; the supplement text will be updated each year. The two 50-page text forms were printed 6/4 with process images on one side of the sheet and halftones on the other. The covers for the

AN EMPHASIS ON WELL-INTENDED RESTRAINT AND SIMPLICITY IS EVIDENT IN MANY OF THE ENTRIES SUBMITTED TO AIGA'S ANNUAL DESIGN COMPETITION.

Above
Detail from Project 15 featured in this book by MadeThought demonstrates how clever thinking and crafted design can create striking results.

viewbook and supplement were ganged on one form. The wrap is just a text sheet trimmed out to size – the two books are wrapped and the stickers are applied at the school.

AIGA—the largest membership association for graphic designers in the United States—is a not-for-profit organization, and so my working relationships with the designers I commission are shaped to a large extent by the constraints of the budget, whatever the state of the economy. Each year we turn out a hundred or more designed pieces—including posters, conference program brochures, and issues-based publications. To do so we depend upon the sponsorship of printers and paper mills, the U. S. Postal Service's not-for-profit mailing rate, and the goodwill (or self-publicizing tendencies, depending on how one views it) of the member designers. We provide designers not only with a modest honorarium and a credit on a piece that has a print run of up to 35,000 but also with license to be creative and experimental. James Victore, who does a lot of work for non-profits and has worked on promotional pieces for AIGA, concludes, "Ah, the joys of working for free. The unbridled creativity, the soft, pliable clients, and the complete absence of the stench of commerce."

WITH GLITZY PRODUCTION VALUES STRIPPED AWAY, CONCEPTUAL WEAKNESSES BECOME ALL THE MORE OBVIOUS.

Project
TRVL, an *Idea* magazine
micro preview brochure

Client
Self-promotion, *Idea*
magazine (Japan)

Design
Michael C. Place

Photography
Nicola J. Westcott,
Michael C. Place

Copy Writing
Nicola J. Westcott

Dimensions
7.3" x 10"
24 cm x 25.6 cm
24 pages

Colors
CMYK and PMS806

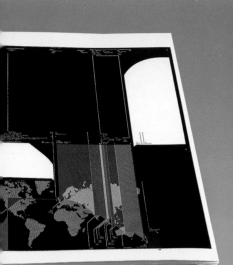

Far left
A restrained and enigmatic design subtly draws the reader in. The typography is confident and understated, hinting at the strength of the internal document. The book is packaged in a clear plastic cover, with only a sticker giving any details.

Left
The use of bold graphic color and contemporary typography on the internal pages is a direct contrast to the austere cover. The pages shout out to the reader in a dramatic series of statements, which develop from broad graphic contrasts to intense moments of the most subtle detail.

Some of the genuinely inspirational and expressive moments come from self-initiated projects. TRVL is the result of a reflective moment during the formation of a new design entity, Build, after a creative sabbatical for the designer, Michael Place.

As people around the world were glued to their televisions on September 11, 2001, watching the events play out live on CNN, Michael Place was creating this project. Having returned from a 10-month trip around the world, the process of creating the project was inspired by readjusting to working again—trying to make sense of events on TV, sitting down in one place for more than a day at a time, and trying to remember how to work a computer. This piece was the end result of that strange time in Camden, London. As it was self-initiated, the TRVL project could be tackled with relative creative freedom. It reflected the experience of a 10-month journey and subsequent return captured through photography and typographic detail. Because cost, production, and the ultimate end use were completely open at the initial design stages, time could be spent on the content and direction. The level of intuitive and spontaneous creation that came from this process allowed the designer to chart new territory and a developing design voice. It was this confidence in the moment of creation that led to a very powerful and cohesive book and an approach that would have been derailed by a traditionally ordered design project. Housed as digital files, it only became a physical book after completion, so budget became a later consideration due to the resulting print and production costs. After discussions with a Japanese publisher, TRVL eventually became a supplement with the prestigious Japanese design magazine, *Idea*. Despite having simple, uncharted origins it grew into a published document through creation for creation's sake.

Project
"3 x 3 Work in Progress"
Seminar Poster

Client
London College of Printing

Design
dixonbaxi, David Sudlow, and Malcom Clarke

Summer begins another round of graduating students from the many universities and design colleges around Britain. Just before this hectic period of the educational year, The London College of Printing, a highly respected design college, approached dixonbaxi to help them with their graduation show and promotional literature.

The students, as was to be expected, wanted to do something different. They were interested in an event that did more than just show a body of work—something that would be relevant to the design industry as a whole. The concept, called "3 x 3 Work in Progress," was a three-night event with each night having three students and three professionals on stage in discussion. The intention was for the boundary between working professionals and graduating students to be blurred during this process. This relationship was a tangible manifestation of the students' commitment to challenge the design professionals' perceptions of the education system.

The committee decided to celebrate the event with a double-sided poster they would send to their extensive mailing list of over 2,000 people.

However, the cost of printing and distributing 2,000 posters proved too high, so an alternative way to promote and invite guests to the event was needed. Rather than create two separate pieces of artwork— one to promote the event and one to invite the guests— dixonbaxi offered the simple idea of designing the invites as part of the poster.

Using an entire A1 printed sheet allowed for a sizable poster, while still offering space at the base of the poster for two invites. Designed to appear as a uniform and complete image, the posters worked with the invites either attached or trimmed off. From an initial run of 1,000 posters, 750 were trimmed to create 750 posters and 1,500 invites. The remaining 250 posters were used as an oversized limited-edition run. The limited-edition posters were sent to key industry figures whereas the invites covered the general database.

Using a cost-effective matte stock available at the printer's warehouse rather than a more expensive uncoated paper allowed for the use of CMYK on one side with three spot Pantone colors on the reverse.

The invites further supported the budget because they were inexpensive to mail and drastically reduced packaging and distribution costs. The limited-run posters eventually became a striking gift with a little extra cachet for key industry professionals.

Opposite
Using a matte stock rather than a more expensive uncoated material allowed for the use of CMYK on one side and three colors on the reverse. Initially shot on a simple, flat yellow, the chance discovery of a wooden desktop shifted the emphasis to a raw and spontaneous application. The single wooden block became a metaphor for the converging themes of the seminar and the potential of the graduating students.

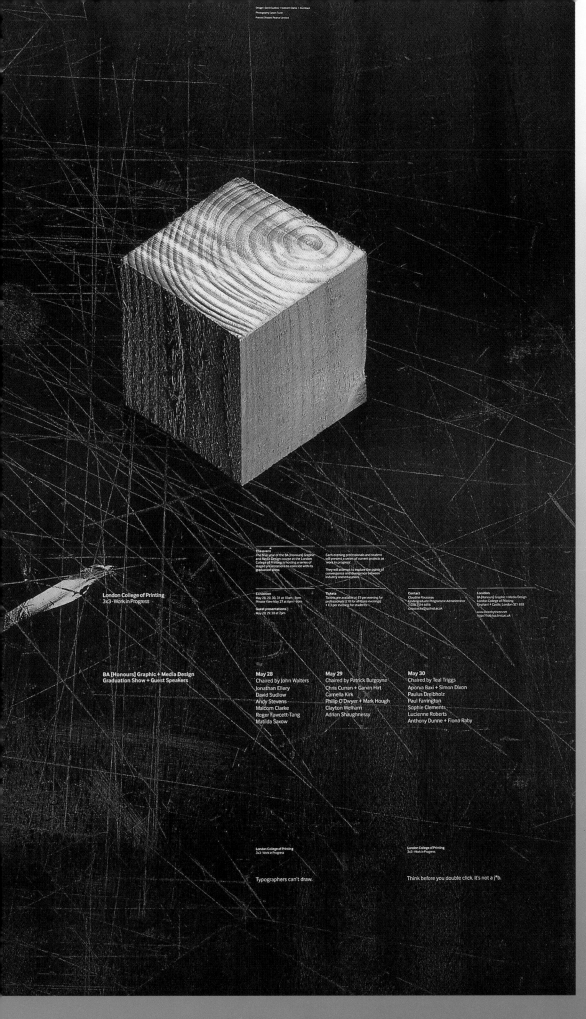

Design | David Sudlow + Malcom Clarke + dsvntaxi

Photography | Jason Tozer

Printed | Robert Pearce Limited

London College of Printing
3x3 - Work in Progress

BA [Honours] Graphic + Media Design
Graduation Show + Guest Speakers

The event
The final year of the BA [Honours] Graphic
and Media Design course at the London
College of Printing is hosting a series of
staged presentations to coincide with its
graduation show.

Each evening professionals and student
will present a series of current projects as
'work in progress'.

They will attempt to explore the points of
convergence and divergence between
industry and educators.

Exhibition
May 28, 29, 30, 31 at 10am - 8pm
Private View May 27 at 6pm - 9pm

Guest presentations
May 28, 29, 30 at 7pm

Tickets
Tickets are available at £9 per evening for
professionals [£18 for all three evenings]
+ £3 per evening for students

Contact
Claudine Rousseau
Undergraduate Programme Administrator
T 020 7514 6696
c.rousseau@lcp.linst.ac.uk

Location
BA [Honours] Graphic + Media Design
London College of Printing
Elephant + Castle, London SE1 6SB
www.threebythree.net
http://nob.lcp.linst.ac.uk

May 28	May 29	May 30
Chaired by John Walters	Chaired by Patrick Burgoyne	Chaired by Teal Triggs
Jonathan Ellery	Chris Curran + Garvin Hirt	Aporva Baxi + Simon Dixon
David Sudlow	Camella Kirk	Paulus Dreibholz
Andy Stevens	Philip O'Dwyer + Mark Hough	Paul Farrington
Malcom Clarke	Clayton Welham	Sophie Clements
Roger Fawcett-Tang	Adrian Shaughnessy	Lucienne Roberts
Matilda Saxow		Anthony Dunne + Fiona Raby

London College of Printing
3x3 - Work in Progress

London College of Printing
3x3 - Work in Progress

Typographers can't draw.

Think before you double click. It's not a j*b.

Above
The reverse of the poster
is a restrained and balanced
typographic exercise. Built
from a series of dimensional
typographic studies, the
treatment was created
physically as black text on
white cubes. The cubes were
then photographed and used
as a single-color piece of
typography. The use of
photography rather than
traditional typesetting creates
an organic feel to the text and
a better relationship with the
still-life reverse.

Project
The Apartments,
Clerkenwell Property Brochure

Client
Garvestone Investments

Design
Williams and Phoa

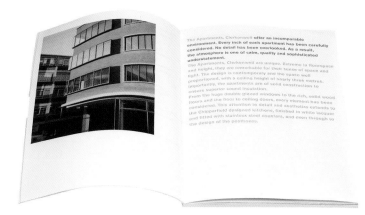

A property brochure for a development designed by David Chipperfield, including showrooms, offices, and 16 high-spec apartments, was produced by Williams and Phoa to give to prospective buyers.

The design, form, and colors of the development itself inspired the brochure design. The architectural approach is very reduced—white, clean, and open—but attentive to details, including materials with high-gloss laminated surfaces, imported flooring, and custom-framed windows. The brochure was conceived as a photographic representation of the development rather than as a guided tour. The photography reflected the architecture, using generous space and light and an understated level of detail.

Working with a limited budget, the designers maximized the number of pages by making the brochure small, enabling the book to have 64 pages.

The designers also decided to print four-color process on only one side of the flat sheet with the other side having only a single color. Taking the pictures themselves with a standard Polaroid camera also yielded a substantial saving on photography costs.

In this case, the restricted budget enhanced the design, encouraging some interesting decisions and creating results very appropriate to the brief. Without the reduction in size to accommodate printing more pages, the book wouldn't have had such a distinctive format. The stock was two-sided, thin Chromolux (gloss/uncoated), which became cost-effective at the brochure's smaller size. Printing the pictures on only the glossy side of the sheet resulted in an unusual pagination, with blank spreads appearing and continuous contrasts of paper texture creating a sense of space and surface.

The photography has an unexpected feel when applied

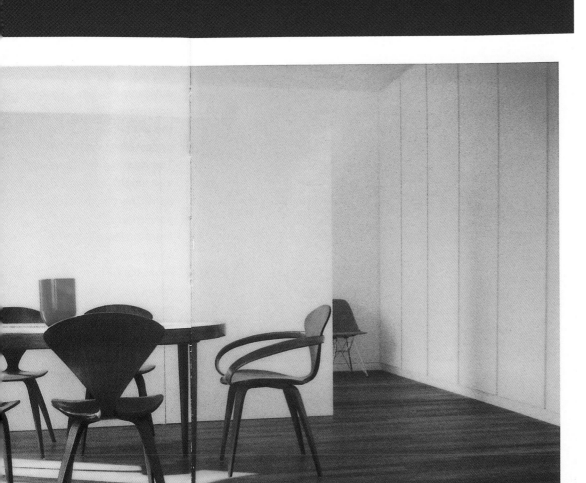

This page and opposite
Well-balanced, refined typography and a confident use of space let the concept breathe. Due to its smaller size (shown actual size), the designers were able to afford to use a more expensive Chromolux paper stock which was gloss on one side and uncoated on the other. This choice of paper is intrinsic to the atmosphere the design, photography, and architecture evoke.

The designers shot the images themselves using a Polaroid camera and, in doing so, not only saved money but also created a beautiful atmosphere that captures the color, form, and atmosphere of the architecture and interior styling.

to the context of a property brochure. The Polaroid's natural limitations of size and quality meant the images concentrated on form, color, and atmosphere rather than sharp detail—an unusual approach for an industry that typically has a very regimented and linear approach to images.

By controlling the design and the outsourced elements of the project, including print and photography, the designers were able to include some higher production quality in other areas of the project, such as a UV varnish and a high-gloss Chromolux stock for certain portions of the piece.

The Apartments, Clerkenwell

Project
The Steamship Mutual
Annual Report and
Accounts 2002

Client
The Steamship Mutual

Design
Williams and Phoa

Left
Images were generated to represent the reflective quality of water and create ambient moods within the report. There is a harmony and atmospheric feeling that creates a moment of contemplation among the more practical text and content.

Below
The text layout annual report demonstrates a simple use of information with a clean, regimented typographic treatment. The typography is simple and refined, giving importance to the message and content rather than shouting its own importance.

The Steamship Mutual's annual report has always been both accessible and beautiful. Over the years the designers have explored various sea and ship themes, ranging from macro photos of sea life, water itself, x-rays of shells, and ship parts.

For 2002, however, a more sober approach was required, prompting the designers to split the document into two parts. The first was the statutory "Report and Accounts," used to deliver the company figures with a minimal production budget. This was followed by a bolder and richer highlight document, to be posted six months later. The specification became a reduced two-color job throughout with no budget for photography, so any imagery had to be generated internally by the design team and achievable in only two colors. They still felt it should have a recognizable Steamship quality, so they explored abstract, watery effects using line work and gradients. The chosen proposal consisted of semi-abstract seascapes of merging color in the vein of the abstract expressionists.

Using two colors and no photographic images guided the design into an area that wouldn't have been considered otherwise and resulted in a beautiful and compelling project with a creative use of the print processes.

A Culture of Constraints
by Teal A. Triggs, Faculty of Art,
Design, and Music, Kingston University

Constraint is a state of mind. Many view constraint as an imposition, as a hindrance, rather than as a catalyst for liberating the process of graphic design. Maybe it is worth considering constraint from a different point of view: instead of a negative, turn it into a positive. Constraint could easily be seen as an approach or a strategy for creativity and for innovation. Take for example the Danish film director Lars von Trier, who in the mid-1990s initiated a rebellion against the excessiveness of Hollywood cinema. The American studios were notorious for producing pictures with big budgets and over-the-top special effects at the expense of interesting plots and character development. In response, von Trier coauthored *Dogme 95*, a manifesto that established a set of rules for filmmakers to enhance opportunities for creativity, including filming on location rather than in a studio, issuing props, using only a handheld camera, incorporating no superficial action, and shooting only in color. For von Trier, having too much freedom meant a loss of purpose, and by imposing restrictions Dogme films would foster a better clarity of purpose.

Similar attitudes to constraints can be seen in other areas of the arts. In a recent anthology of new British fiction writing entitled *All Hail the New Puritans* [1], 15 writers were restricted to 10 rules as an authorial challenge. The main intent of the book's editors was to ask writers to "strip their fiction down to the basics" to see if "something exciting emerges." The basic principles of fashionable storytelling processes were immediately thrown into question. New consideration was to be given to narrative form (plot lines), textual simplicity (by avoiding authorial asides), and grammatical purity (by avoiding any elaborate punctuation). In this way constraint became a positive re-evaluation of the writing process and opened up new avenues for personal interpretation.

So how might constraint be used as a positive strategy for graphic design? There is no doubt that constraints are an integral part of the graphic design process, whether it has to do with the client's stated intent, limited budgets, and time restrictions, or the intrinsic properties of materials, production processes, or the nature of the vehicle chosen for dissemination. Constraints are also embedded in the communication process. The composition of the target audience presents certain challenges and may determine the way in which the message might be conveyed and disseminated. Equally, there are cultural constraints, which are learned conventions shared by a cultural group or community and absorbed into everyday practices. Physical constraints present another aspect, which have of late been highlighted by the format and technical specifications required when designing for the Web. Indeed, basic design elements and principles of design themselves present a set of constraints. Take grids, for example. The Swiss designer Karl Gerstner rebuffed his critics who suggested that typographic grids were limiting and left no freedom or scope for design. He felt the issue was more concerned with the difficulty "in finding the balance between maximum formality and maximum freedom" and suggested that "grids allow for great variability, allowing for more and freer interpretations." [2] Equally, the way in which type is chosen and used is dictated by recognized conventions associated with readability and legibility, including length of lines, use of capital letters to begin sentences, optimum line and word spacing, and so on. This becomes especially important when communicating certain types of information such as that which may be found on pharmaceutical leaflets, health and safety posters, or even warning signs for landmines.

However, these fundamental constraints might also present a starting point for developing new and perhaps more effective ways of conveying such life-saving information. In terms of design education, there is a balance to be achieved between the constraints found in the professional world and the perceived freedom of an academic institution. It is frequently the case that a misleading sense of professional design practice is represented in the classroom. The problem is highlighted when students graduate or go on to do work placements and find it difficult to reconcile what they have experienced in the classroom and the client-based constraints of the professional design studio. Such tensions have been fueled over the last decade by debates surrounding the designer as graphic author. As a result, many students find that expectations have shifted and their perceptions of professional practice are skewed. The difficulty is to reconcile the freedom offered by self-initiated work with that of client-based objectives. Students in a college environment are often in a luxurious position where they are able to freely explore new ideas, processes, materials, and production techniques without the restrictions often presented by a commissioning client. This is an opportunity that must be taken advantage of. Students need to understand that experimentation or play is an essential and investigative stage of the design process. Yet play must be framed in terms of specific limitations to foster an exploration of one or two ideas in some depth. To do so then presents a range of quantifiable observations from which learning can then proceed. In 1967, the British graphic designer Anthony Froshaug wrote in his essay "Typography is a Grid" that designers must unquestioningly "admit constraints: then, having admitted, fill with discovery."[3] For designers and students, constraint is the only way to move our understanding forward.

Notes
(1) Nicholas Blincoe and Matt Thorne (eds.) (2001) *All Hail the New Puritans*. London: 4th Estate.

(2) Karl Gerstner quoted in Hans Rudolf Bosshard. (2000) *The Typographic Grid*. Zurich: Verlag Niggli, p. 21.

(3) Anthony Froshaug (1967) "Typography is a Grid," reprinted in Michael Bierut, Jessica Helfand, Steven Heller and Rick Poynor (eds.) *Looking Closer 3: Classic Writings on Graphic Design (1999)*. New York: Allworth Press, p. 179.

Below and opposite
Details from Project 46 by Teal A. Triggs.

IN TERMS OF DESIGN EDUCATION, THERE IS A BALANCE TO BE ACHIEVED BETWEEN THE CONSTRAINTS FOUND IN THE PROFESSIONAL WORLD AND THE PERCEIVED FREEDOM OF AN ACADEMIC INSTITUTION

Project
TLM Electrastars

Client
Hydrogen Dukebox Records

Design
Yacht Associates

Copy Writing
Doug Hart

Printing
Rad Printing

Dimensions
5" x 5.6" x 0.4"
12.6 cm x 14.3 cm x 1.1 cm

Colors
CMYK centers in white
outer case

Special Process
Die-cut hole in sleeve

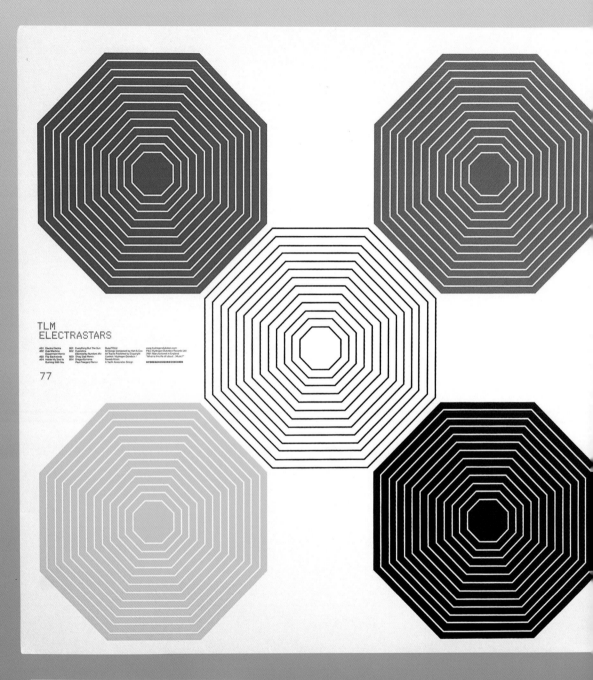

Yacht Associates tackled a fast-turnaround release for an underground electronic music label, Hydrogen Dukebox Records. The design budget of £500 was both challenging and exciting. The core idea had to be concentrated and streamlined with maximum impact. Here, inspiration was found in the graphics and information language of reprographics and print.

Printers' run-off sheets were used as inspiration. A simple graphic symbolism was developed in the form of detailed octagonal shapes in CMYK and white and became the project's visual identity. The LP design came first, using simple shapes to imply the experimental and electronic nature of the recorded compositions. The CD followed, and a different approach was chosen with a special packaging solution that was both innovative and cost-effective. Continuing the reprographic theme, the designers chose to have four different color CD label centers, each representing one of the four CMYK colors. The design suggested the CD was actually an ink cartridge for an unknown machine. As a refreshing twist, the designers avoided the accepted norm and produced no paper inlay; the money saved was instead used for a central die-cut. A cardboard slipcase was adapted from existing grids, with a new cutting guide created to continue the octagon motif and highlight the four-colored centers. Type was kept to a minimum and placed on the spines to keep the CD covers clean.

From start to printed samples, the project took only four weeks, and the final result was short-listed for the Special Packaging Award in the Music Week Creative Awards 2002. Although a very simple adaptation of an accepted medium, it was a fresh approach, a covetable object, and a real head-turner in an overcrowded marketplace. Owning a set of all four colors has become a must-have among the dedicated underground fan base. Even the designers are missing a black-centered disc from their files.

Project
"Design in the Public Service:
The Dutch PTT 1920-1990"
Exhibition Catalog

Client
Design Museum, London

Design
Hamish Muir – 8vo

Author and Exhibition Organizer
Gerard Forde

Printing
Drukkerij Rosbeek BV,
Nuth, Netherlands

Lithography
Nemela & Lenzen,
Mönchengladbach, Germany

Print Run
2,000

Dimensions
11.5" x 8.5"
29.7 cm x 21 cm

80 pages with colored
end papers, thread sewn
in 16 and eight-page sections

Colors
PMS 3275, process
magenta, process cyan,
and four-color process

Materials/Processes
Cover: gray board with
exposed green linen hinge;
front board screen-printed
one color (opaque white) with
tipped-on die-cut sticker,
printed lithography four-color
process on gloss art
Text: 150 Scaldicote Matte

This project was intended
to celebrate the quality and
innovation of the Dutch Postal
Services design system over
its 70-year history. Known for
their beautifully considered
and rigorous approach to
design and typography, 8vo
seemed the logical choice for
a project that reflected one of
the best corporate identity
programs of the last century.

From the beginning, the
designers took a systemized
approach to the design. The
print budget allowed only 16
of the 80 pages of text to be
printed with a four-color
process. To avoid a separate
section of color plates in an
otherwise monochrome book,
the four-color work was split
into two eight-page sections,
with adjacent sections printed
in either process cyan or
magenta. This allowed the
four-color work to be threaded
throughout the book.

The relationship with the
Dutch printer Rosbeek was
important to the final outcome
in terms of both technical

advice and maximizing the
budget. At the time, equivalent
quality print was cheaper in
Holland than in the United
Kingdom. Rosbeek was one of
several Benelux-based printers
the designers knew from a
previous book design project.

To maximize the budget,
the designers structured the
design with the grid system,
which led to some
unpredictable outcomes.
The identity of each chapter in
the book was defined by using
a tint panel at the bottom of
each page to hold images; the
height and color of these were
varied by chapter. This process
helped to carry the chapters
across the breaks in sections
printed in single- or four-color.

Working outward from a set
of technical constraints and
applying logical rules to
design development led the
designers to produce work
that transcended the obvious.
In this case, the restricted
budget was not a hindrance
at all, and the response to it
defined the design.

Opposite top
A vibrant but sophisticated
cover is highlighted by the
interesting contrast between
an uncoated hard cover that
is screen-printed and a sticker
that is four-color process.

Opposite bottom
The internal layouts are
organized by splitting the
text and images into two
opposing sections on the
page. Each section of the
book uses different
typography based on
the same grid and design
principles, creating an
experimental and
unconventional result.

Left
The ingenious system with
which the book is put together
allowed the four-color work to
be threaded throughout
the book.

Project
Conference Video

Client
Virgin Special Projects

Design
Why Not Associates

This spread
Scratchy hand-drawn
typography, found objects,
and luscious imagery combine
to enhance the powerful and
exotic photography.
Its twisted and experimental
aesthetic with double-exposed
and overlaid images creates
a rich textural landscape.

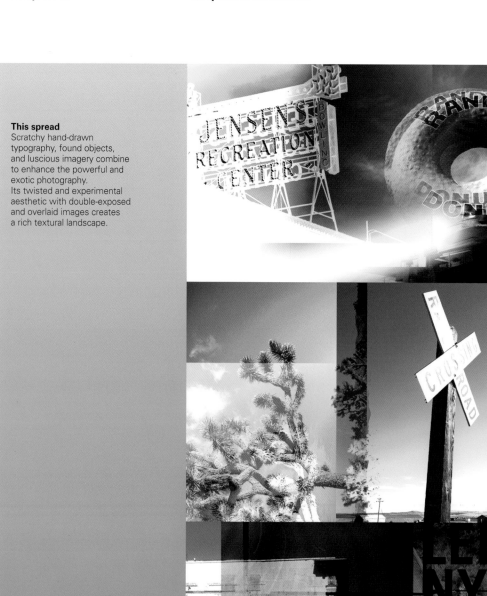

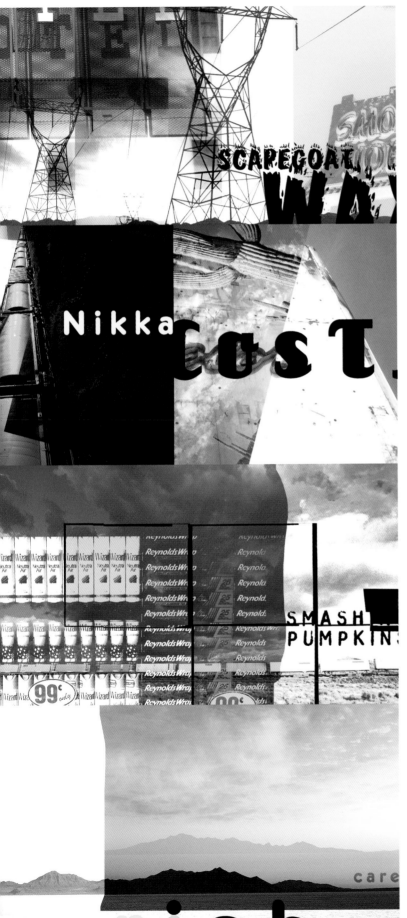

VIRGIN SPECIAL PROJECTS 2001

For three years running, Why Not Associates was asked by Virgin Special Projects to design and direct their annual worldwide conference video. This involved editing a 30-minute film and creating titles and descriptive idents for each of the featured artists.

Each year the designers were given an open brief and allowed to experiment in different ways, be it with typography, film, or three dimensions, enabling them to explore new techniques and approaches.

For 2001, they chose the theme of a road movie. The title sequence would begin the story, the idents that punctuate the conference video would develop the narrative, and the end titles would form a conclusion. Deciding on a car as the lead, they charted its progress through different environments as it traveled from the hustle and bustle of city life to the calm of the sea, via forest, desert, and suburbia. The budget meant that the project's filming had to be done on a shoestring. The film crew was kept to a minimum with crew members doubling up their roles. The images were shot on a range of cost-effective formats, including Digital Video, Super 8 film, and 16-mm film, using the camera operator's own camera. There was no time for location scouting, so the team covered a huge area of California in five days on a wing and a prayer, shooting what was appropriate along the way. The spontaneity and creative discovery was the essence of a true road movie.

Once the team returned to London, the post-production and finishing were completed within a couple of weeks. The bulk of the editing was produced in Avid, an online editing software package, while the titles and idents were created in-house at the design firm's studio using an After Effects desktop system. To save costs, a minimum of footage was transferred from film. The Super 8 footage was transferred to a digital format by first projecting it on the inside of a blacked-out restroom and then re-filming it onto Digital Video. Creatively, it worked perfectly, giving a great, flickery home-movie feel and lending a raw quality. The production budget was eased by the low cost of transferring the Digital Video footage to the desktop computer system.

Project
Human Imprint –
Specification

Client
Damian Higgins,
a.k.a. Dieselboy

Design
WeWorkForThem:
Michael Young,
Michael Cina

Illustration
WeWorkForThem

Copy Writing
Damian Higgins,
a.k.a. Dieselboy,
WeWorkForThem

Reproduction
Film

Print Run
2,000

Dimensions
12" x 12"
30.5 x 30.5 cm

Two-color sleeve, one
two-color sticker, custom
die package, and four folds

Materials
Carton board

Right
The record label identity
is a humanized and
contemporary illustration
that can be used with ease
in the range of single-color
and graphic applications that
record sleeves dictate.

Inspiration for this project came from a long working relationship with Dieselboy, a.k.a. Damian Higgins, a drum and bass artist, and DJ. *Project Human*, a mix CD, was his seventh release in a series of DJ releases.

Drum and bass music can traditionally have a rough, dark, and cold feel to it. The client wanted to shift from this stereotype and create a warmer, more humanistic feel, setting the mood and tone for his new company. The identity had to reflect a progressive record label but rise above the clichés of the drum-and-bass genre.

Budgets help define the parameters of a project rather than affect the way WeWorkForThem designs. After hearing what the client wants, the designers make a written outline which becomes a treatment they refer to when looking at the initial round of ideas and concepts. At the conception stage, the sky is the limit and everything is possible, and only after exploring each idea do they become selective. They often work up hundreds of ideas to create the one solution that they eventually mold and refine.

When creating the 12-inch (30.5 cm) covers, the designers wanted to be sure the design would be reusable for later printing without losing its visual punch and expression. The original idea was to swap one Pantone color and create a series of releases that were defined by the Pantone colors and a numbering system to keep track of them. However, the project shifted creatively after the designers rethought the effect of the budget and resolved the production into one standard cover and a sticker that would identify and update the releases. Using a lowest common denominator in terms of production techniques focused the design around the record label trademark. The use of the identity as the main design element created a clear program and made the best use of their new identity.

Left
Typographically, the text in this cover sticker is systemized and has an austere, contemporary look that complements the elaborate nature of the graphic texturing on the album cover.

Brand: HUMAN
Brand: www.humanimprint.com

HUMAN

Digital sounds for analog life

This spread
The use and reuse of
a developing pattern
derived from the record
label identity has a hypnotic
effect. It becomes a readily
recognizable series of
symbols that are carried
across a series of
record releases.

Project
Self-promotional postcards
and presentation cards,
first and second series

Client
Self-promotion

Design
Estudio Peón: Nuria
Gonzalez, Griselda Ojeda,
Monica Peón, Nacho Peón

Illustration
Estudio Peón

Copy Writing
Estudio Peón

Reprographics
Offset

Printing
Litosanca

Print Run
200

Dimensions
Presentation cards,
first series:
3.25" x 2.2"
8.5 cm x 5.5 cm

Presentation cards,
second series:
3.5" x 2"
9 cm x 5 cm

Postcards:
5.5" x 4"
14 cm x 10 cm

All two-page

Folding or Finishing
Matte plasticized

Colors
First series:
2/1 Pantone 8300 C
and black

Second series:
2/0 Pantone red 032 U
and black

Materials
Phoenix Imperial
semi-matte 250 gsm

Release Date
1 February 2000
2 April 2001

As a new design team, Estudio Peón needed a promotional piece that would be intriguing, memorable, and unusual. The idea of the butterfly cocoon became a good metaphor for the emerging studio. The studio works as a collective, so each member agreed to design his own presentation card to reflect his style and personality within the collective. Grouped into a series of cards, the designs were given away in sets.

When developing the first series, the studio discovered it was cheaper to get a larger legal-size sheet printed in offset rather than individual cards. This allowed them to design the cards and postcards according to a specific size and space, printing them with two colors on one side and a single color on the reverse.

The second series used the same card principle but was printed with two colors on a single side. The designers were working on another project that had space on the printing sheet that would be wasted if it went unused, so the studio used this extra space to print the cards. The project they were piggybacking had a red and black color scheme, so they used those colors. The designers found that two inks were more than enough—the work could look very different according to style and approach, and the range of visuals spoke for themselves.

Working on the first series for about two weeks and the second series for about four days, the idea was to make them fun, collectible items. As the designs varied greatly, the perception became that the project budget was large because each card appeared different. The result was people asking for the complete set as if they were collectible baseball cards.

Left and above
By using a different designer for each card, the design and images have a varied look that represents both the individuals and the collective. Personal and experimental, they all stem from the same inspiration of a butterfly cocoon, but are expressed in a series of free-form illustrations.

Project
The Grips—
New Young Black Sound

Client
Firebrand

Design
Richard May at
Pixelsurgeon.co.uk

Design Manager
Rina Cheung at
Pixelsurgeon.co.uk

Photography
Richard May

Illustration
Richard May

Copy Writing
The Grips, Richard May

Print Run
5,000

Dimensions
4.75" x 4.75"
12 cm x 12 cm

Colors
CMYK

Materials
120 gsm
matte-coated stock

The Grips album promo sleeve began life as a photo collage composed of monochrome Polaroid shots and black-and-white prints developed at the local photography shop. The general approach was to create a record sleeve image and internal artwork that were simultaneously trashy and elegant, exactly reflective of the band and their music.

The Grips album was the ideal Pixelsurgeon project. Neither the band nor the record company had a great deal of money at their disposal, but Pixelsurgeon seems to specialize in "building wicker men from matchsticks." Photo shoot? Local bar. Development? Local main-street photography shop. Their combined experience has also taught them that many of the overheads associated with a typical design project, no matter how small, can easily be avoided. If anything, the budget enforces a kind of stripped-down, Zen-like approach to the way the team works.

It took only three or four days of production for the designers to create this bold graphic package for the new underground band, who may otherwise have had to resort to a homemade cut-and-paste approach. The intriguing thing is that the designers actually used this rough-and-ready method and achieved a great effect. Thanks to the happy accident of creating artwork with a raw approach, the project was a huge success. Despite low standards and production costs, the skill of the design and composition raised the design level to that expected of a large, well-established band.

Communication with the client was 99 percent of the production process. By working closely with the band to gain their trust and by conveying the intent and nature of the design, the creative team could push further with limited resources.

Opposite top
Shot with low-grade equipment and processed at a local photography shop, the cover image has the immediacy and directness that clearly reflects the band's music.

Opposite bottom
Using layered and texturized images, the layout is built on a montage of photographic elements. Typographically bold, the reverse cover is as direct as the front cover.

Left
The interior design is a pared-back and restrained graphic image.

DESTROY EVERYTHING
STAINLESS STEEL
STRAP DOWN
LET'S GET ADDICTED
BABYLON FALLING DOWN
HEAT
EJECT
SHE WALKS RIGHT THROUGH ME
REPRISE
SOMETHING TO DO
RUNNING AHEAD
FU BABY

PROMOTIONAL USE ONLY
PUBLISHED BY COPYRIGHT CONTROL

ALL TRACKS PRODUCED BY MARK SPIVEY
EXCEPT 02 AND 07 PRODUCED BY TIM KERR
ALL TRACKS ENGINEERED BY JOHN PAUL BRADDOCK
RECORDED THROUGHOUT 2000 AT RUBBER BISCUIT STUDIOS
NOTTINGHAM, ENGLAND
THE GRIPS ARE NATHAN, WAYNE, MARTIN, DAN AND JEZ
ALL SONGS BY JONES / MUSSON / EDWARDS / COX
ADDITIONAL GUITAR ON DESTROY EVERYTHING AND FU BABY
BY GRAHAM LANGLEY, COURTESY OF SAVOY GRAND
TRACK ZERO CONSTRUCTED BY MARK SPIVEY
DESIGN AND PHOTOGRAPHY BY RICHARD MAY
AT PIXELSURGEON CREATIVE CONSULTANTS LTD
FOR MORE INFORMATION CONTACT
DIRTYNOISECONSORTIA@HOTMAIL.COM
FOOD@PIXELSURGEON.COM
WWW.PIXELSURGEON.COM/THEGRIPS

THE GRIPS
NEW YOUNG BLACK SOUND

THE GRIPS

KISS THIS NOISE
SHOOT FORTH THUNDER
GOSPEL BOX
SONS OF SHE WOLF

FOR PROMOTIONAL USE ONLY - WWW.THEGRIPS.CO.UK - DESIGN BY PIXELSURGEON.CO.UK
For Bookings and Management Contact dirtynoiseconsortia@hotmail.com

Project
An ocean in straight lines

Client
BD4D (By Designers
for Designers) event six
held at the ICA London,
in conjunction with
onedotzero

Animation/Design
James Warfield, WIG-01

Images/Photography
Andrew Townsend, WIG-01

Copy Writing
Leigh James

Specification
A flash animation

Running time
Approximately
three minutes

By Designers For Designers (BD4D) events are a series of lectures, discussions, and seminars for designers to share thoughts on the creative thinking process and execution. The events feature a section called "Three-minute Madness," where a designer has a three-minute slot to highlight a new piece of work that is usually experimental in nature.

WIG-01 decided to take the "Three-minute Madness" title literally and produce a short animation on the subject of madness. As a free-form project, the animation was to entertain and show the creative community what WIG-01 is capable of. The initial reason for WIG-01 to create the animation was to work on a project purely for fun, without any client interference. They didn't make the animation for financial gain; it was made purely to enjoy creating new work.

The budget didn't affect the creative thinking behind the project; it just affected the production of the concept or idea. A large budget helps to decorate and furnish the original idea, but sometimes these frills don't necessarily help the communication. In the case of WIG-01, the idea was the driving force.

Because the animation was made for a screen, the designers were not restricted by a production budget. The fact that the project was for a screen and not for print was the most important aspect in reducing the effect of the budget because they could create digital animation. The use of digital technology and the delivery of the project as an animation file dictated that the designers' time would become the largest budget consideration. The duration of the project was about six weeks, but they worked evenings and weekends so their day-to-day projects would remain unaffected.

They didn't have a set vision at the beginning of the project for how the finished work would look, so they didn't have any expectations. The piece was allowed to evolve as they experimented with different ways to animate. The project developed into a sophisticated blend of words and images subtly animated into a series of vignettes.

Opposite
Esoteric typographic phrases and statements guide the viewer through a developing journey. The images twitch and shudder as each moment is revealed in turn. The animation is an organic statement that expresses a very personal approach.

like an ocean in straight lines.

washed,

spat concrete,

Project
Mini Prospectus 2002/03

Client
Ravensbourne College of
Design and Communication

Art Direction
MadeThought

Design
MadeThought

Photography
Lee Mawdsley

ravensbourne
college of
design and communication
www.ravensbourne.ac.uk

Ravensbourne is a University Sector College with a
distinctive personality and creative tradition, located on
a single site campus within easy reach of central London.
Our mission is to creatively apply digital technology
to design and communication.

2002/03

ra
ens
u e.

v
b
rr

Ravensbourne College commissioned MadeThought to create a teaser publication to help support and direct users to its online prospectus.

The budgetary restrictions of the project required a maximum print cost of 80 pence ($1.15) per unit. This required MadeThought to carefully select paper stock and an economical format to create a substantial, tactile object with a lasting visual impression.

As imagery was lacking on the prospectus Web site due to download restrictions, MadeThought commissioned a photographer to capture the spirit of the college. These images were then placed into a 32-page full-color book with no text. This acted as a taste of the environment, showing a brief reportage of its location, the building, the equipment, and work the college has produced.

The details about the college and its courses were then applied to the dust jacket, which folded out to make an A2 poster, giving it dual functionality for career fairs and exhibitions. By creating the two different objects— booklet and poster—as one entity, the designers created an award-winning and visually powerful design with the functional aspects needed to maintain a rigid budget.

This spread and next page
The typography is thoughtfully placed but retains a contemporary feel. The book, printed on a high-gloss paper, exudes quality and contrasts with the cover poster, which is printed on uncoated stock.

ravensbourne
college of
design and
communication
2002/03

www.
ravensbourne.
ac.uk

ra
ens
ue.

Foundation

The Foundation Diploma course at Ravensbourne gives you the practical scope to explore options, assess your strengths and identify where your potential lies for your future development. Our programme lets you explore a variety of ways of seeing and thinking about the world around you, and develop a personal visual language with which to express your ideas. You'll experience and understand a range of art, design and communication subjects and practices, while developing and maturing your own style and individuality. Through access to processes, media, materials and techniques, you'll acquire self-motivation, time management and team-working skills with which to prepare your portfolio and your next step into higher education or work.

Fashion

Fashion at Ravensbourne is about the creative development of the individual, the designer of the future. The achievements of our students and graduates are evidence of our success in nurturing a sense of curiosity and infinite possibility for the design proposition. Our option of a two-year intensive as well as a three-year course of study is the only one of its kind in the UK.

Graphic Design

Graphic Design at Ravensbourne encourages you to explore, probe and understand clients' needs beyond their 'surface' appearance. The course has a strong design bias, stressing the importance of effectiveness and solutions for real need, emphasizing the value of analysis, description and process, as well as management and organisational skills.

Moving Image Design

Moving Image Design at Ravensbourne is about stimulating education in design for the moving image industry through encouragement of experimentation. Distinctive from other courses, our programme emphasises the balance between design, narrative and technology.

Broadcasting

Broadcasting at Ravensbourne is about creating for an industry undergoing immense change, and the potential this represents for those who wish to be at the forefront. The programme provides the route for anyone seriously interested in taking a personal journey towards employment in the new media world. In the first decade of this new century, broadcasting is at the crossroads of creativity, social responsibility and digital technology. New technologies enable a diversity of story-telling to flourish to meet an ever-growing demand for rich and well-crafted content.

In a new age, the imperative is to deliver content in a form appropriate to the way people want to receive it: interactive as well as passive, mobile as well as fixed. This affects how we create and produce content, and how it generates value from both customer and client perspectives. This rich tapestry presents us with extraordinary opportunities and genuine challenges, as reflected in our redesigned programmes. We encourage new generations of creative people to achieve the skills that offer employability in whatever the future may bring.

2002/03

ravensbourne
college of
design and communication
www.ravensbourne.ac.uk

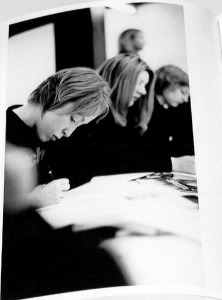

Above
A beautifully designed
and cleverly constructed
book and poster.
The poster crisply folds
down to become the dust
jacket for the book. When
the poster is opened, it
reveals a full-color interior
with further information
on the college.

WE ARE ACTIVELY
DEVALUING THE COST
FOR CREATING NEW
MEDIA PROJECTS

About BD4D
The goal of BD4D is to bring designers together to feature their latest work and to discuss their passion: creativity. There is also a major emphasis on encouraging the creative community to mature to new levels through physical interaction. There is a synergy that takes place at BD4D events as people can bounce ideas off one another and form collaborative efforts. These free events have been hosted in cities across the world, including Paris, London, Sydney, Toronto, Los Angeles, New York City, and Frankfurt.

Our Perspective
We have been fortunate to gain a bird's-eye view of the global new media design community through BD4D events and thus are able to see how the current restraints on project budgets are affecting the outcome for these projects and the designer's view of the industry as a whole.

We heartily agree that budgets for projects have been cut significantly since the raging dot-com industry came crashing down in mid-2000. We have observed two interesting things occurring as a result:

1. Designers are working for cheaper rates, because they're being forced to bid lower and lower to win creative contracts

Left
Interface sketches for
Project 58 Last FM.

2. There is still an influx of talented new designers who are starting creative agencies.

Designers in New Media Are Dropping Their Rates

We have seen firsthand that because of the desperation to find work, designers are charging less and less for their work. This has a huge negative impact on the industry, because we are actively devaluing the cost for creating new media projects. This is quickly being noticed by potential clients, who are simply looking for the lowest bidder. There is an even more insidious result to projects going to the lowest bidder—the quality of the work, as a whole, will decrease. Even though the cost of creating quality new media work has decreased, the time to actually create it has remained the same. Therefore, if designers are dropping their charging rates, they are slowly being forced to work longer hours for less money. This as a whole is going to affect the creative industry in a very negative way. One possible outcome is that we will see fewer and fewer truly innovative client projects.

The Continued Influx of Talented New Media Designers into the Industry

Even taking into account the above statement regarding rates, we are still seeing a global influx of amazingly talented creatives into the new media industry. We feel that this is connected to the fact that many designers have chosen the new media industry because it is one of the few professions where they can exercise what they are passionate about: creativity, innovation, and beauty. Through BD4D events, we have seen that designers are willing to sweat and bleed for their creative endeavors, despite the lower pay for their work. This, of course, does not keep the rates for creative projects at a high level. One possible result of dropping rates for new media work is an exodus of highly talented designers to creative fields with better pay.

Summary

We feel that the budget constraints being placed on the new media industry are decreasing the overall quality of the work being produced. However, the designer is a creative animal that will subsist in creating, despite lower wages. This leaves us in an uncertain situation. Only time will tell.

Above
Details from Project 14 featured in this book. A flash animated movie that was created specifically for a BD4D event by design team WIG-01.

Project
Woven trend-forecast book

Client
Laura Miles

Art Direction
MadeThought

Design
MadeThought

Photography
Joakim Blockström,
Lee Mawdsley

Illustration
MadeThought

Printing
Perivan Creative Print

Print Run
150

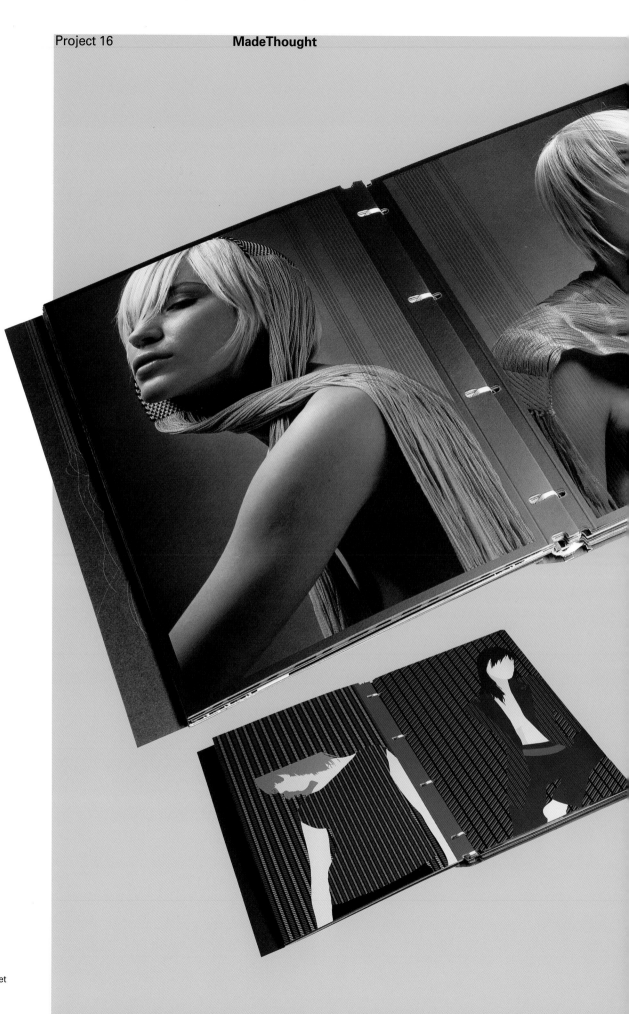

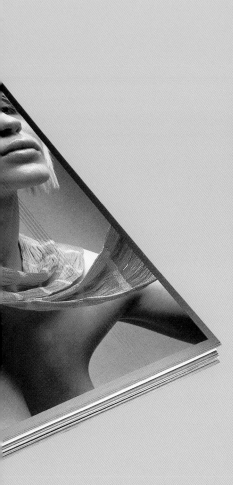

Right
The designers paid special attention to the finishing of the book and discovered an innovative way to bind loose sheets together using ribbon. This not only provided a unique and updateable format, but it also reflected the handcrafted qualities of textile designer Laura Miles's work.

Below
A sumptuously crafted project, the cover is an understated moment of design. The designers found that collaboration with the printer throughout the project was the key to not only meeting their high standards of quality but also to being as efficient with their resources as possible.

Left
The layouts use a combination of photography and illustration, which creates a rich tapestry of images that weaves throughout the book.

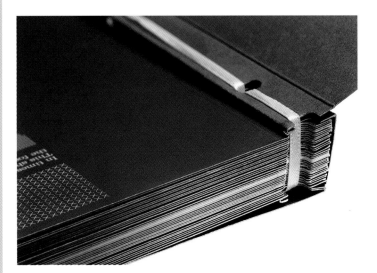

Textile designer Laura Miles commissioned MadeThought to conceptualize, design, and art-direct a new trend-forecast book for the fashion and textile industry.

It was produced in a strictly limited quantity of 150 copies, which sold for around £1,000 ($1,450) each. Although the retail value was very high, a very small budget was assigned to the production of the books. This meant some hard work in achieving a highly sophisticated publication, creating a desirable, esoteric object that couture fashion houses would find appealing.

To manage the execution effectively, MadeThought produced a series of illustrations and art-directed the photography throughout. Taking the creative lead, they originated a very unusual and practical approach to the production process. Innovative packaging and binding methods were employed—the book was contained in a linen-covered box, screen-printed externally, and lined with a full-color portrait. The book itself was bound with ribbon, evoking the handcrafted qualities of Laura Miles's work. This also created a functional loose-leaf system for adapting or updating elements.

Printed by Perivan Creative Print, who worked extremely hard to ensure the project would be of the utmost quality, *Woven* is a good example of a successful collaboration between client, designers, and production teams. Issue Number Two is in production.

Project
Boxman:
Edinburgh International
Film Festival 2002 e-flyer

Client
Edinburgh International
Film Festival

Design
Hoss Gifford – h69.net

Specifications
Flash animation

Size
787 k

Duration
79 seconds

Software Used
Macromedia Flash MX,
Adobe After Effects, Sonic
Foundry Acid Pro, Sonic
Foundry Sound Forge

**Technology
Required to View**
Flash Player, version 6

**Distribution, Concept,
and Animation**
Hoss Gifford

Photography
Mike Henderson

Typeface
999 Group

Soundtrack
Hoss Gifford

For designer Hoss Gifford, The Edinburgh International Film Festival is the best and worst client to work for. Best in that they give huge creative freedom, are very nice people, and offer a great subject. Worst in that there's a limited budget. How do you animate something to compete with the stunning cinematography that is on show in the festival itself? The simple answer was, do not try to compete with film; use the medium of the Web to its full advantage.

This meant that the concept had to be extremely strong and represent the fully immersive, inspirational nature of good cinema. It wouldn't be enough just to have a strong execution. The low-budget production necessitated a strong concept, so spending a substantial amount of time on the concept is something done willingly—including generously free brainstorming in the pub.

Gifford viewed the key to working on a tight budget as always loving the project to a point where he was prepared to put some of his own spare time into it. It was produced in his (limited) spare time, using only assets and equipment that he already owned. Instead of commissioning

any third-party illustration, photography, video, sound effects, or music, he produced the complete set within his own system.

While in development, he produced an animation style that lent itself well to small file sizes and allowed for longer animations with more depth. Another success of the project was a strong soundtrack, with Gifford allowing up to 50 percent of the production time for the soundtrack and effects. A further aid to completing the project within budget was the reuse of some animation from the e-flyers created for the 2001 festival.

Wherever possible, he would find "cheats" on the concept to reduce production time. For "Boxman," he used a video clip of himself walking to trace and create a smooth motion for the walk cycle. He then removed the video and a realistic walk animation remained. Minimizing production time by not animating a scene inside the cinema and just using sound instead not only took less time to produce but significantly reduced the file size of the animation.

Opposite
The format was an animated short, used as an e-mail teaser, for a film festival whose central character is an animated figure encountering a series of typical film scenarios. The simplicity of the character belies the complexity of the fluid animation. In this case, less is more with stripped vector graphics describing both city and hero. The witty ending mixes live-action footage with the digital hero to great effect.

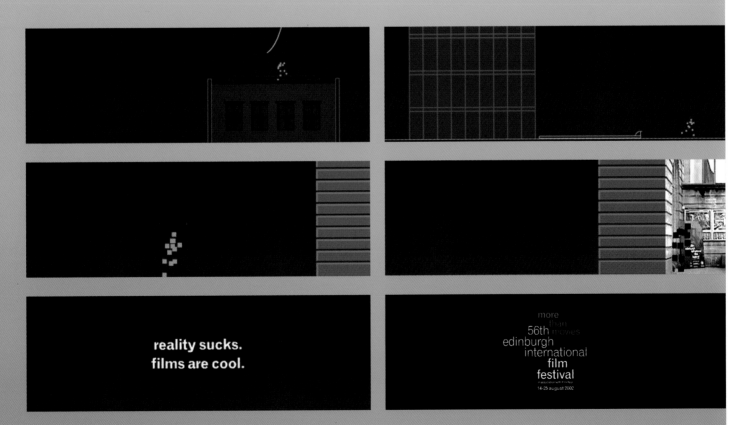

reality sucks.
films are cool.

more
than
movies
56th
edinburgh
international
film
festival

14-25 august 2002

Project
Activ walking frame

Art Direction
Mike Woods

Design
Mike Woods, David Tonge,
Aaron McKenzie

Model Making
Chris Hill—
Benchmark Model Making

Photography
Moggy, Dario Rumbo

Opposite
Walking frame prototype. Form and function elevate this basic and often neglected product to a new and relevant position. Not only does the form look and feel beautiful, the walking frame also works to help the user increase stability, accessibility, and confidence about the daily tasks of life.

Left from top
Initial sketches. The designers moved through several sketch iterations before the right balance of pragmatic concerns and design aesthetic were found. The balance of form versus function was intrinsic to the design process.

Initial sketches were inspired by a series of design mood boards. Visual reference and style approaches were collated to inspire the design team.

The team mapped the different types of user by creating personality charts. These map the likes, dislikes, and environment of each of the different types of user.

It seems that people with disabilities are often unfairly stigmatized because the products they have to use daily are designed to satisfy functional need rather than any aesthetic quality—they are "aids" not "artifacts."

Tangerine, a London-based product design team, worked with the "Design for Ability" research group at Central St. Martins School of Art & Design on a program that studied the lifestyles and aspirations of people with disabilities. A diverse market was revealed, with a range of consumer preferences, just like any other market sector.

This was a research and development project with the barest minimum of a budget but a distinctly important outlook and goal. The team used skills and techniques garnered from experiences with other retail and consumer products to apply a new way of thinking to the design and production of existing disability products. As they developed the design, they focused on the end result and user rather than on the preconception of what the product should be like.

This alternative walking frame concept was used to evaluate their research, and it shows how needs can be turned into wants through combining functional benefits with stylistic improvements. The use of innovative materials, distinctive styling, and some lateral thinking created a very functional product that could fit well in a general marketplace for well-designed products and, at the same time, be a specialized piece of equipment.

type 3 - **active**
31 - 50 • educated • parents • mortgage • politically knowledgable • adventurous

cars	housing	interests	media	purchasing
		reading (sci-fi)	Guardian the Mirror	**?** "Which?"
	house, flats, bungalow (mortgages, renting)	computers	computers magazines / entertainment guides	informed decisions
Ford Austin Renault Peugeot Nissan		DIY gardening sports instruments	**television :** 2 - 4hrs / educational Dr Who detective series	Sainsburys
				Argos Littlewoods catalogues / John Lewis dept stores
		art galleries theatre	Radio 4 Classic FM	brands fairly important

type 4 - **intelligent**
41 - 50 • educated • readers • mortgage • keen to influence • confident

cars	housing	interests	media	purchasing
Rover Honda Daihatsu Fiat Ford		reading (classics, alternative literature)	the Times local papers	**?** "Which?" or on appearance
	flats, houses (owners)	board games	women's & disability mags	pleased to make right decisions / brands fairly important
		ballet theatre	**television :** 2 - 4hrs / current affairs alternative comedy documentaries	specialist shops
		cooking		dress to look smart / High st stores
	some voluntary work		Radio 3, 4 Classic FM	**would pay upto 75% more for better appearance**

Project
Pieces of Halfproject
Web site

Client
Fourskin Nation,
Threadless, and Halfproject

Design
Zylonzoo

Photography
Carl Chua, Jose Illenberger,
Melvin Delos Santos

Illustration
Niccolo Balce, Drew
Europeo, Rex Advincula,
Melvin Delos Santos

Hosting
Philmetro.com

"Pieces of Halfproject" is a collaborative Web site pushing inspiration for the local and international design community. The name stems from it starting as pieces of artwork from two individuals that were combined into one, producing a new whole.

The need for a local design community was really the biggest inspiration that Zylonzoo had when they started curating Halfproject. The collaboration was meant to serve as a creative playground, and the concept grew from there. The team's main purpose was to have a place where designers and artists could interact and collaborate on projects, even if they didn't meet personally, and display them on a Web site for others. They believed that by doing this they would create a culture where designers and artists could have fun but, most important, could also learn from each other and enhance their creativity.

As everything is published online, they only have minimal physical expenses. To cover the hard costs, such as servers and hosting, they search out companies who can sponsor areas of the Web site. The sponsors themselves, although having no effect on the design, do benefit from the relationship by having a link on the Zylonzoo Web site to their own. Zylonzoo also often trades services, offering design or ideas in return for something they need. The other operating expenses are shared by the Zylonzoo crew members.

Everything starts with conceptualization as the Zylonzoo crew members discuss the ideas they want to implement on the site and agree on a path they are going to take. They use basic materials and approaches so they can continually reinvent how the process works. The key for them is enjoying the core idea and loving it. From there, they can build an audience that enjoys it, too.

Above and right
The Halfproject Web site contains a wealth of creative experiments, many of which are collaborations with other like-minded designers, such as the playful but well-executed illustrations that are reminiscent of Manga art.

Left
T-shirts and sticker sets complement the Web site, creating collectible merchandise by using the site's bold graphics and icons.

Project
Meetup identity design

Client
Meetup

Design
EGO

Copy Writing
EGO

Colors
PMS 186 and black

Release Date
Spring 2002

EGO was commissioned to design a logo and identity system for Meetup, which was started as a result of recognizing the tendency of like-minded individuals to gather and share interests. Meetup facilitates these gatherings by providing a low-profile, Web-based structure for organizing meeting places and times and helping people find others who share their interests in their local area. The logo and identity system were created to harmonize with the overall user interface.

The logo and identity of Meetup could not interfere in any way with the existing identities of either the groups who were "meeting up" or the establishments where they were meeting. As Meetup is a behind-the-scenes engine that drives the human traffic to the retail spaces, the identity could not be imposing but had to be memorable and unique. There is no need to sell Meetup to the public or retail businesses, so the logo did not need to be too flashy or overt. EGO tapped into the difference between selling and telling.

The Meetup logo design was based on the ubiquitous "HELLO my name is" name tag. This name tag's shape and colors have already become a symbol of greetings and introductions between strangers. The Meetup name tag was standardized with set proportions and colors, ensuring consistent reproduction, to help build the brand based on this already familiar icon.

The logo comprises two elements: a standardized name tag and the word "Meetup," which is always handwritten in the name field. This handwritten element always changes and reflects the people-powered philosophy behind Meetup. Meetup does not impose its logo upon individuals, but instead provides a blank canvas upon which an individual may create his own "logo" in the same way that Meetup provides opportunities for groups to meet. It is a dynamic, ever-changing logo, and each new Meetup logo is a surprise.

The use of limited colors and the fulfillment of the identity by an individual have created a very cost-effective brand that has a strong residual effect.

Right
The designer has taken an everyday and well-known object and reinvented it, producing a strikingly simple and clever brand identity. This demonstrates that whatever the budget, the concept is still the most important element of design.

Using a limited color palette and having each business card holder write "Meetup," the designer has created a constantly evolving and physically interactive identity.

WE HAVE COME TO SAVE THE PLANET

Frank

RICHMOND, VA

ATARI 2600

NEW YORK, NY

PEZ HEADS

HAROLD

CANDY

RANCHO SANTA MARGARITA, CA

THE JEDI ACADEMY

ATLANTA, GA

HELLO
my name is

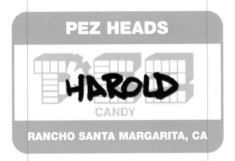

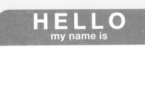

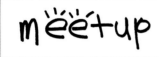

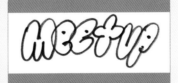

PANTONE 185	CMYK 91M76Y	WEB SAFE FF 00 33
WHITE		WEB SAFE FF FF FF
PANTONE BLACK	CMYK 100K	WEB SAFE 00 00 00

Project
Gartner 2001 Annual Report

Client
Gartner

Art Direction
Bill Cahan, Bob Dinetz

Design
Bob Dinetz

Photography
Frank Schwere

Copy Writing
Tony Leighton,
Bob Dinetz, Gartner

While companies look for ways to cut
expenditures in response to economic downturn,
the majority of our client relationships remain intact.
In most cases, they strengthen.

Gartner

The smaller size and
format of the annual
report creates a feeling
of precious quality
while the interplay of
quirky images and
sedate typography adds
an air of openness. The
pages are interleaved
with images, bold color,
and translucent pages
that combine for a fresh
approach to a typically
dry subject.

TO OUR SHAREHOLDERS: Gartner had a good year in difficult times, and we are more confident about the year ahead. Our businesses have—before and since September 11—proven to be quite resilient. Despite a negative impact on sales in September, historically our biggest month, revenue from continuing operations rose 11 percent to $952 million. EBITDA grew 14 percent to $142 million. We believe this is due to the value our clients place on good advice, the payoff of good investments, making value and relevance our priorities, and changing our cost structure to deliver consistent growth and predictable profits.

PREDICTABLE PROFITS It was clear to us last February that the technology boom was weakening and the economy would follow. We took immediate strong action to change our cost structure yet maintain our record of growth. We divested non-performing businesses, most prominently TechRepublic. We decreased staff by approximately 8 percent, lowering operating expenses by about $40 million. From being a company accustomed to driving high growth with high investment, we turned toward consistent growth and higher and more predictable profit through moderated investment. Our financial health, measured primarily by 14 percent annual growth in EBITDA, is testament to how well that strategy is working.

THE DURABILITY OF GOOD ADVICE Our prospects remain strong in fiscal 2002 for the simple reason that our clients need what we offer: practical advice that helps them preserve their revenue and earnings. In the five boom years that have just passed, we were most often called upon to help enterprises make intelligent choices about technologies that would enable their growth strategies. Today, we are working with the same clients to help them make decisions about how to evaluate cost and investment, strengthen and renegotiate relationships with suppliers, maximize the productivity of their technology, and prepare for the rebound with smart deployment strategies. While IT investments show little or no growth in 2002, they will nevertheless account for about 57 percent of all capital spending and 6 percent of GDP in the United States. Even companies cutting costs dramatically are still spending more on IT than they were two years ago. Each of them needs advice—on how to spend $1 million to earn $5 million, on how to avoid spending $5 million and remain competitive, on how to extract the greatest value from their existing assets. Gartner is better equipped and better positioned than any other company in the world to provide exactly that advice.

INVESTMENTS PAYING OFF During the past two years, we made a number of significant investments to sustain our lead as the world's top research and advisory firm. Some of those investments were unpopular because they reduced earnings-per-share. Today, they are paying dividends. We put in place a global infrastructure that enables us to manage a billion-dollar company. The result: the financial and human resource capabilities (continued on inside back cover)

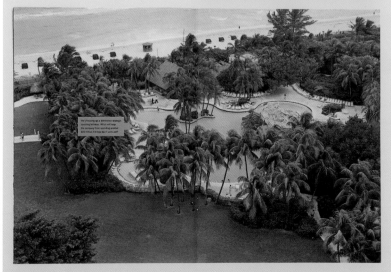

Maybe it was a change in the economy. Or maybe it was readers' increasing lack of patience as more and more annual reports used thematic stories to relate company information. Regardless, the key message for Gartner in 2001 was put right on the cover in two sentences, and it stated their continued success despite being in a tougher business climate.

Gartner's well-known technology research and information have become increasingly crucial as the economy forces everyone's margin of error to narrow. To communicate the vital role for Gartner's knowledge, the document highlighted key information that unsuspecting business people didn't have while making multimillion-dollar technology decisions.

The simple elegance of the layout and subsequent design was a direct reflection of the need to consider budget requirements. The final document has a sophisticated, finished look that bears testament to the use of well-considered moments of design and visual narrative. The use of design and content, instead of print finishes, delivers a report of lasting beauty. A transparent vellum section is dedicated to Gartner's five business units and features a plan that increases the overlap between the established research group and the company's other core competencies.

Project
X-Games Athlete
Training Log and Poster

Client
Nike Inc., Oregon

Art Direction
Steve Tolleson

Design
Dora Drimalas

Copy Writing
Holly Hudson

Photography
Tammy Kennedy,
Dora Drimalas

Printing
Graphic Center,
Emeryville, CA

Colors
Journal:
six-color throughout

Poster:
six-color, with
two-color overprint

Materials
Journal: 70 gsm Bright
White Coronado text

Poster: 65 gsm Coronado
Vellum cover

This spread
A distinctive blue plastic cover heralds the Nike training observation log. The internal booklet blends irreverent sound bites with the more inspirational aspects of extreme sport in a snappily packaged graphic layout.

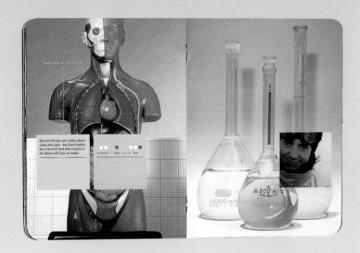

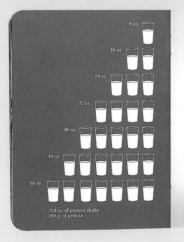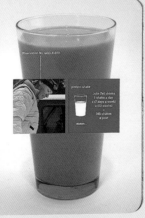

While working on materials for the 2000 X-Games, Nike gave Tolleson Design the challenge of exploring a brand identity that would appeal to their antiestablishment target market.

Traditional marketing to this audience took for granted any real athletic ability of the athletes and, instead, focused on the extreme nature of their sport. Tolleson, however, decided to take the creative in a different direction, celebrating the athletic achievements and training regimens of the Nike X-Games team and recognizing their credibility as real athletes.

To promote the notion of unparalleled athleticism, Tolleson designed an Athlete Training Log that highlighted the team's athletes individually and documented their particular training habits that keep them at the top of their game. Taking the form of a small booklet using both typography and still-life images, the team countered the very tight budget by shooting much of the photography in their studio

conference room on a newly purchased digital camera.

The Athlete Training Log idea appealed to Nike, and they felt very strongly about promoting the concept. However, real budgets had yet to be assigned to this real sports category. The challenge became two-fold: to educate the consumer about the athletes and to promote the events that Nike was sponsoring in selected cities around the country.

Tolleson decided that the best way to stretch the budget as far as it would go was to use the printer's press sheet from the Athlete Training Log as the base imagery to create a set of new event posters. This made sense from both a budget standpoint and a consistent visual-messaging standpoint. Taking these press sheets, they silk-screened the practical information for the athlete appearances that were scheduled in different cities, creating a new design and promotion from the existing printed elements.

This page
Using the printer's press sheets from the booklet, the designers were able to extend the budget to produce a set of event posters. The practical information was silk-screened onto the press sheets using two colors, creating a new set of promotional posters.

Observation No. 6453-X-010

When the snow melts, you'll find Rob Kingwill stream side, casting about for his next meal.

0.000" 6.000" 12.000" 24.000" 30.000" 36.000" 42.000" 48.000" 54.000" 60.000"

Actual size of fish Reported size of fish

Observation No. 6453-X-006

When he's not mountain biking, hiking or surfing to stay in shape, Mike Michalchuk can be found creating furniture masterpieces with his chainsaw.

Orange Juice Design

Project
i-jusi magazine

Client
Self-promotion

Design
Orange Juice Design

Photography
John Pauling Photography

Reprographics
Sparhams

Printing
Fishwicks

Print Run
500

Dimensions
A3
16 to 24 pages

i-jusi (roughly translated as "juice" in Zulu) is an experimental graphic design magazine published anywhere between two and four times per year by Orange Juice Design, Durban, South Africa. *i-jusi* aims to encourage and promote South African graphic design to interested creatives and writers worldwide. The *i-jusi* initiative is part of Orange Juice Design's commitment to developing a design language rooted in the South African experience. Designers, design students, illustrators, photographers, and writers are encouraged to create in total freedom and to explore their personal views on life in a free and democratic South Africa. Increasingly, *i-jusi* provides a platform for creatives (both local and international) from diverse backgrounds to collaborate in exchanging cultures, ideas, and imagery.

The strictly noncommercial 16-page A3 magazine is published in a limited print run of around 500 copies per issue. In the spirit of ubuntu (we exist relative to one another), the *i-jusi* team

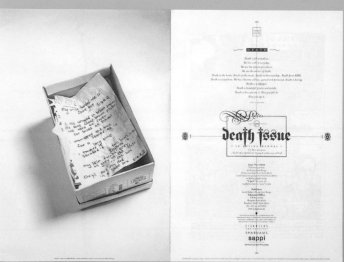

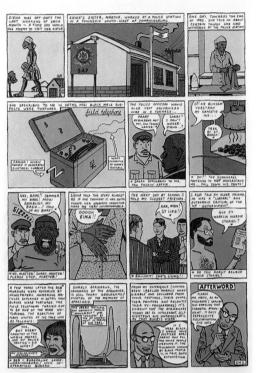

members contribute their services gratis. There is no budget per se for production (or anything else!). The paper is sponsored by South African paper giant SAPPI, and the repro and print by Orange Juice's primary print supplier, The Fishwicks Group, which produces all of the studio's commercial work.

The magazine content is left up to the creative freedom of the contributors. As a publisher, Orange Juice likes to be far more progressive than average on content and South African historical issues, but they need to be sensitive to the wishes of their cosponsors. Ironically, and despite their history, South Africans enjoy a more free interpretation of political correctness than many first-world societies.

This spread and next spread
An eclectic burst of creative thinking and execution heralds the arrival of each new issue of *i-jusi*. Using a large broadsheet format and different stocks, the magazine has a distinct presence. Each issue tackles the creative challenge of producing the magazine on its own merit and maintains a fresh and intriguing blend of styles.

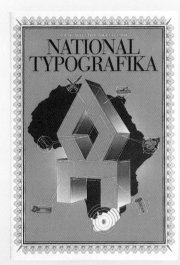

Project
Seasonal point-of-sale: Portugal
Season Two
(point-of-sale and windows) and
Iceland Season Three (point-of-
sale only)

Client
Levi Strauss Europe

Design
Aboud Sodano

Photography
Self-portraits, with technical
help from Antony Crolla

Reprographics
Point-of-sale:
ESP Ltd., part of SP Group

Window point-of-sale:
Adroit Photo Lithography

Printing
Canvas backdrop:
SP Group and Archive Printing

Dimensions
Point-of-sale:
23.75" x 16.8"
59.4 cm x 42 cm

Portrait, windows:
70.9" x 47.2"
180 cm x 120 cm

B windows: 3-D

Colors
CMYK

Materials
Point-of-sale and
gloss laminate:
300 gsm Hello Silk

B windows for Home
Laundry Season Two:
gloss clear 450 _m (.01755")
PVC with the backdrop
printed onto cotton canvas

C windows:
350 _m (.01365")
matte white PVC

Aboud Sodano had been
working with Levi Strauss in
Europe during the launch of
their engineered jeans,
consulting on their advertising
campaigns and art-directing
shoots on behalf of their
advertising agency, BBH.
In all areas, they were trying
to eradicate the ranch-style
imagery in their stores. They
wanted something simple,
high-impact, and, above all,
relevant to 15- to 22-year-olds.
"We wanted to create
imagery that represented
a cross section of their
audience. We definitely didn't
want pretty models in pretty
locations," explained Alan
Aboud. To accomplish this,
they proposed embarking on a
tour of European cities with
the intention of documenting
European youth. Their quest
began in Amsterdam. Several
months later, they arrived in
Reykjavik and ended the tour

in Lisbon. Observed Aboud,
"Seeing kids of the same age
in different cities really
illustrated that, no matter
which city we visited, kids
were kids," and music and
fashion were always at the
forefront of their thoughts.

As with their operation in the
United States, Levi Strauss
Europe was affected by a
huge downturn in sales, so
budgets were tight. Aboud
Sodano felt that if they went
with an A- or B-list
photographer, the travel
budget would be nonexistent.
Instead, they decided to
propose the campaign as self-
portraits, thus eliminating the
need for a large photographic
budget. They enlisted the help
of a photographer friend,
Antony Crolla, to help with the
technical issues and then
planned the trips. Again, the
budget could not withstand

large model fees, so the
designers proposed casting
real people rather than
models. In advance of their
trips, they contacted local
production companies for
help. They posted flyers at
schools and colleges and
had announcements on local
radio looking for participants.
The result was overwhelming.
On one casting day in Lisbon,
the team viewed 1,000
people. The final result was
impressive. Aboud elaborated,
"They were not spectacular
shots—that was not the sole
intention—but the people
were great. The images were
not just the normal fashion
shots that appear in most
shop windows. These
were real people in real
environments. It took a brave
creative director, Caroline
Parent at Levi's, to stand up
and champion our cause."

Opposite
By choosing to cast real kids, as
opposed to models, and having them
take self-portraits, the designers
created the opportunity to make
a strikingly simple but effective
campaign. With this approach, they
avoided the prohibitive cost of a typical
photographic shoot, which would have
rendered the concept unfeasible.

This spread
The backdrops and people
are truly eclectic and maintain
the integrity of the concept
by showing kids from all over
Europe in their own environment,
as opposed to emulating the
scenes in only one location.

Project
Pogo

Client
Pogo Technology Ltd.

Design
Marcus Hoggarth
at Therefore

Dimensions
4.75" x 3.75" x 1"
12 cm x 9.5 cm x 2.4 cm

Weight
240 g

Materials
Main body: PC/ABS
Cover: silicone rubber

Stylus: carbon
fiber/ABS/stainless steel

Specifications
4Mb Flash Memory
16Mb SDRAM

32-bit ARM7 RISC 75
MHz processor

Rechargeable lithium
polymer battery

Three days
standby battery life

Two to five
hours talk time

LCD color, front-lit
transflective screen

320 x 240 pixels
screen resolution

Dual-band
GSM/GPRS modem
module (900/1800 MHz)

Web Browser: HTML
v3.2, Flash v4,
Javascript v1.1

Web Security: Supports
HTTPS, 128-bit SSL

MP3 player:
MPEG layer 2/3

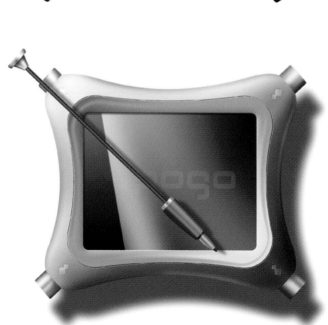

Top left
The form of the device
appeals on an emotional
level as well as being
ergonomically designed,
allowing for its
multipurpose uses.

Bottom left
Each corner of the Pogo
cleverly hides a different
function: stylus holder,
antenna, power button,
and stand. This ingenious
solution is not only
functional and ergonomic
but has also been
designed to maximize
the effectiveness of the
product while minimizing
the cost of materials.

Mobile technology is increasingly snapping at the heels of the desktop-bound computers with more and more powerful and user-friendly devices appearing all the time. Pogo, a British start-up and the name of their revolutionary product idea, wanted to express their unique software and data compression technology in a form that represented a new paradigm for mobile Internet products. The goal was to bring to the consumer market an affordable device that offered instant access to the real Web whenever and wherever the user wanted, full color, and speed that leaves a home computer in the dust—not forgetting that it should also function as a mobile phone, mp3 player, e-mail tool, organizer, and games machine. Having little knowledge of producing products, limited resources, and a short window of opportunity, Pogo approached design firm Therefore to help them achieve their ambitious goals. Due to cost, lead-time issues, and production volumes, all of the electronic components in Pogo had to be off-the-shelf. There was a lot of hunting for the right components, because the device was literally going to be a sum of its parts.

The injection-mold tooling for Pogo was always going to be a big cost and lead-time item. To reduce these factors, Pogo was designed to require simple tooling. By simplifying the construction and design of the device, the team was able to reduce the number of components and get tooling for about a third of the cost, in a timeline of four to six weeks rather than the typical 12.

The stylus was another interesting micro project for the designer. One of the big features of Pogo was that the device would be as tactile and comfortable to hold as possible; hence, all of the connectors were moved to the corners. They didn't want to compromise that with a stylus fitted to the side of the product and were also conscious of the extra tooling cost and complexity of having a slide-in-pen area on the product. The solution was to have the stylus skewer through the middle of the product, being thin enough to weave through the internal components of the device. The problem was that to make a stylus that thin would make it vulnerable to snapping. A solution was found by looking at composite materials.

A carbon fiber rod was used as the main element of the stylus; it was stiff enough and could take huge loads (bending) and still be flexible enough to return to its original shape. The other plus point was that it was inexpensive; it was "pultruded" (extruded, but pulled rather than pushed) so you could get miles of the fiber at a fraction of the cost

of stainless steel. It was mainly used as an engineering material and was also commonly used in kites, but no one had ever used it for this kind of product. The stylus was capped at both ends with stainless steel, and a plastic tip and grip were slid on. The result was an incredibly thin, high-quality stylus that didn't compromise the size of the device but enhanced the overall quality and was also fun to play with. The short timelines led to a production cycle of only 11 months from briefing to retail. By paying special attention to both materials and the function of each of the components, the limited resources didn't compromise the product. In fact, it helped inspire the designer to find clever and sophisticated solutions, achieving both high quality and affordability.

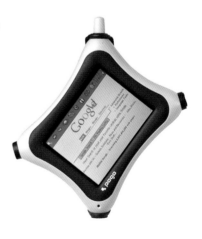

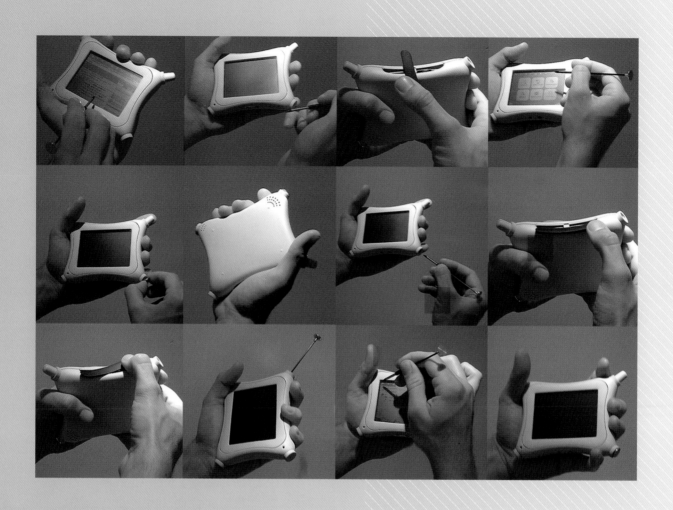

Left
The exploded view of the Pogo shows all of the components, each of which had to be sourced from off-the-shelf materials due to the limited funds. Each component has a function; nothing is superfluous, making sure that budget goes as far as possible.

IT IS OFTEN HARD
TO HAVE A TANGIBLE
COST AGAINST THE
LEVEL OF TIME AND
DETAIL THAT TYPEFACE
DESIGN ENTAILS.

I believe that it is in everyone's interest to be paid fairly for the work he or she does. As designers we are at a slight disadvantage to, say, engineers because our work is visual and its benefit cannot be measured with absolute certainty. A car either works, or it does not. If it has a problem, the mechanic will fix it. But who is to say whether one design is better than another? Design is a subjective matter. As typeface designers we are in the fortunate position that our clients, fellow designers, appreciate the value of our work. When a corporate client has to be convinced of the benefits of a custom typeface, the design aspects are secondary. It is the financial and legal advantages of owning a typeface that usually sign the checkbook.

Our work ranges from small half-day projects to large, multistyle typeface families lasting several months. Of course, like everyone we prefer working on large projects. It allows for more accurate planning and timing, thus optimizing the profit made on the job. On small jobs the profit margin is minimal, if any at all. We do these jobs in order to maintain client contact and because we are typographers. There is nothing more depressing than poor typography in a logotype that will be plastered all over the United Kingdom. Quite often, refinement of a logotype takes twice as long as was budgeted because the nature of the work is purely visual and there are as many opinions on the shape of a curve as there are eyes judging it.

A custom typeface project is a different matter. It normally consists of three parts: initial concept and design, drawing of all the characters in different styles, and, lastly, engineering. It is the conceptual stage that in budgetary terms presents an unknown. Its success depends largely on how well we interpret the brief. We are, therefore, interested in working closely with the designer to avoid any waste of time. Once the concept is agreed, the second stage, refining the concept and drawing all the characters, is largely a matter of labor. The client usually has little influence on this work. Changes are cosmetic and do not affect the budget. But as with everything in life, there are exceptions to the rule.

We designed a new typeface family for a German company consisting of six weights of Sans Serif and two weights of a matching serif. Initially, we designed the entire Sans family as this was more urgently needed. In parallel we started to develop a matching Serif font; it had to feel as part of the same design as the Sans. We submitted some initial designs to the designer in charge of the project in order to understand which stylistic direction the concept should take. This was carried out on a few letters only. After some discussions it transpired that something more classic was required and we redrew the design to be of a more baroque (transitional) design. At the same time we expanded on the character set for the client to be able to judge the design more fairly. Now, in our opinion, this design was it. It incorporated many of

the Sans features and at the same time was a highly legible text face. On top of that it was elegant. After a few days of testing the client came back to us with a wish to amend the concept to be more of a Modern. We made the appropriate changes and eventually the client was happy. By this time, the budget was hugely overspent. We then expanded the character-set and added an Italic. At this stage the client started to make comments on individual letterforms. Much of the comments were based on direct comparison with the Sans design. And judged at large sizes. On both counts this approach is wrong when dealing with a text font. We argued more or less every single letter, and more or less each one was modified two or more times. Now the budget had totally collapsed, and there was still some more drawing to come. Fortunately, there was some engineering work to be done. This is pure technology and can be measured. And it is complicated, so no one will argue with the costs.

The budget on the above project was always on my mind. It is often hard to have a tangible cost against the level of time and detail that typeface design entails. The subtle levels of nuance and detail are hard to equate to pure man-hours or fixed costing as each case is different. Only during the creative process does the full extent of the time start to become clear, but once on the path, you are committed. I don't design for the love of mankind. It is a way of earning by doing something I love to do.

Project
Abnormal Behavior Child

Client
Self-initiated project

Design
Niko Stumpo

Photography
Niko Stumpo

Illustration
Niko Stumpo

Right
Bold colors and strange hand-drawn characters define the visual language created by Abnormal Behavior Child. The designer shares the budgetary and personal freedom that many Web designers enjoy when creating their own sites.

Abnormal Behavior Child is a personal design portal initiated three years ago by Niko Stumpo, and it is constantly mutating and growing with the designer. It has become an ongoing research program dealing with the online interactive experience and design process within a digitally enhanced visual environment. Like many other self-initiated projects, this one is driven by the designer's passion and hunger to continuously learn and experiment. "Passion and creativity don't always need budgets," explained the designer, although he has intentionally chosen to work within the digital space to avoid facing traditional production costs. He continued, "I like this medium because it enables me to create my own projects without having to face financial constraints." The work is highly expressive and playful with bizarre characters populating the graphic environments.

When it comes to doing photography the designer relies on his own experience, finding locations and collaborating with other designers to produce the shoot. Again, technology provides the freedom to create while using limited resources. Occasionally, Abnormal Behavior Child is brought to the printed medium, but the designer seems to have found the perfect solution. He is fortunate enough to combat any budgetary constraints by having a printer next to his house who loves to print his design work.

Project
Mickey's Hangover
advertisement

Client
Mickey's Hangover

Design
Mike Tomko at Nocturnal

Illustration
Mike Tomko and free clip art

Typeface
Helvetica Neue Family

Printing
Java Magazine

Print Run
Local magazine run
(approx. 27,000 per issue)

Dimensions
10" x 10"
25.5 cm x 25.5 cm

Colors
Pantone Yellow
Pantone Black

**The best chili cheese dog, done by the
numbers. Go to Mickey's Hangover:**

4312 North Brown Avenue
South East Corner of
5th Avenue and Drinkwater
Downtown Scottsdale

Food, Spirits, and Fun. Open Late Nightly.

"Mickey's Hangover is an incredibly fun and low-budget bar. That right there should have clued me in to the limit of the funds!" exclaimed designer Mike Tomko. Mickey's is a culmination of old, velvet couches, grandma's lamps, and a bar with resin-covered '70s and '80s ads and news clippings. There are framed pictures of famous Mickeys on the wall, from Mickey Rooney to Mick Jagger. On top of all this, Mickey's is situated in the heart of Old Town Scottsdale, Arizona, amidst the sexy and trendy clubs. That is what it prides itself on. The designer was asked to develop a series of advertisements, geared towards the bar's clientele, that was fun and promoted theme nights, special events, and the menu.

As sometimes happens when launching directly into creative concepts, the budget hadn't been discussed. The designer met with the owners and promoters to put together a few ideas. Coming back with numerous photo-driven visuals raised the issue of budget. "I knew that wouldn't fly," explained Tomko, "especially if we needed photography, including models." An alternative was to look at stock images, but even these proved too costly. Facing an impending deadline for the first ad, he didn't even have time to shoot them himself. Nocturnal offered a trade. With no budget to speak of, the designer bartered for more creative freedom as his payment. Researching alternatives led to a new direction, in which he decided to hand-draw elements and use free, funky clip art. Although the ads were to appear as full-page, the newly negotiated budget limited the design to two colors. Having developed a strong, irreverent visual language of hand-drawn illustrations and clip art, the two-color limitation worked to enhance the design.

This page
The limitations of budget led the designer to rethink using full-color photography, in favor of irreverent and kitschy hand-drawn and clip-art elements.

Project
SIX advertisements
and invitations

Client
SIX

Design
Mike Tomko at Nocturnal

Photography
Mike Tomko and stock

Typeface
Helvetica Neue family

Printing
Advertisements:
944 Magazine

Invitations:
Kelley Printing

Print Run
Advertisements:
local magazine run, approx.
35,000 per issue

Invitations: 2,000

Dimensions
Advertisements:
9" x 10.9"
23 cm x 28 cm

Invitations:
5" x 5" and 6" x 4"
12.5 cm x 12.5 cm and
15 cm x 10 cm

Colors
CMYK

SIX, a glamorous and sophisticated bar, wanted to reintroduce a new and improved Monday night, featuring live jazz with the occasional DJ spinning jazz. Nocturnal was commissioned to create a series of ads and invitations that exuded the style and atmosphere that the night would have. Inspired by listening to plenty of jazz and hanging out in the dark and moody environment designer Mike Tomko developed some striking yet subtle imagery. Rich reds and blues blended with the photography and contrasted with the deep black backdrop, evoking laid-back nights listening to cool jazz. The typography complements the photography and is intentionally restrained. Having limited funds, the designer offered a trade

publication a barter—his design services in exchange for a series of full-color full-page ads. In this way, the designer created the means to develop richer, more evocative imagery. With no opportunity to employ a photographer and models for the images that would be predominant in the design, Tomko took it upon himself to take the photography and recruit some friends to serve as models. Once the images were manipulated to create the desired graphic effect, it was hard to tell that they were taken on a limited budget. Whereas the advertisements were printed as part of the barter agreement with the magazine, the invitations were printed alongside another job to keep their production costs to a minimum.

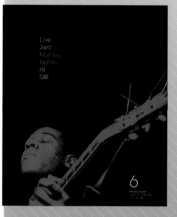

Above right
The invitations were designed in this square format to fit into standard envelopes and were printed along with another project to save money.

Opposite
The designer chose to shoot the photography himself, having no resources to employ a photographer. Even so, the result is not diminished. The dramatic black-and-white imagery is overlaid with vivid reds and blues to capture the cool, moody atmosphere of SIX.

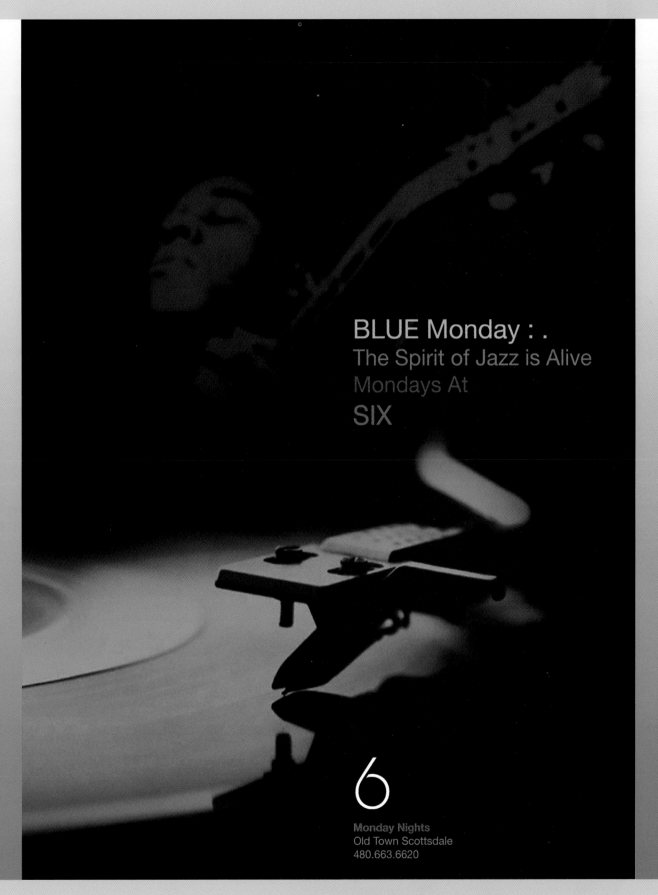

BLUE Monday : .
The Spirit of Jazz is Alive
Mondays At
SIX

6
Monday Nights
Old Town Scottsdale
480.663.6620

Project
Ad2 Invitations

Client
Ad2 Phoenix

Design
Mike Tomko at Nocturnal

Illustration
Mike Tomko at Nocturnal

Reprographics
One Source

Printing
One Source

Print Run
1,000

Dimensions
8.5" x 5.5"
22 cm x 14 cm

Colors
CMYK

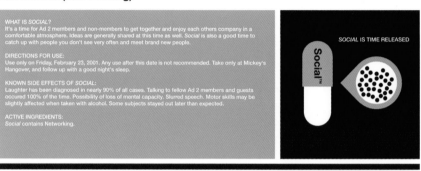

Social™ PRESCRIPTION FOR A HANGOVER.
USE ONLY AS DIRECTED BY AD 2 PHOENIX AND MICKEY'S HANGOVER.

CONTENTS:
Ad 2 social (one evening)

WHAT IS *SOCIAL*?
It's a time for Ad 2 members and non-members to get together and enjoy each others company in a comfortable atmosphere. Ideas are generally shared at this time as well. *Social* is also a good time to catch up with people you don't see very often and meet brand new people.

DIRECTIONS FOR USE:
Use only on Friday, February 23, 2001. Any use after this date is not recommended. Take only at Mickey's Hangover, and follow up with a good night's sleep.

KNOWN SIDE EFFECTS OF *SOCIAL*:
Laughter has been diagnosed in nearly 90% of all cases. Talking to fellow Ad 2 members and guests occured 100% of the time. Possibility of loss of mental capacity. Slurred speech. Motor skills may be slightly affected when taken with alcohol. Some subjects stayed out later than expected.

ACTIVE INGREDIENTS:
Social contains Networking.

Social™ *SOCIAL* IS TIME RELEASED

ONE EVENING PER CARD. STORE IN A COOL, DRY PLACE. PROTECT FROM DIRECT SUNLIGHT. KEEP OUT OF REACH OF SENSIBLE ADULTS.

Ad2 is a club for young advertising professionals. The Arizona Chapter commissioned Nocturnal to create a series of invitations. The designer knew a few of the board members, which streamlined communication and helped the process by giving the designer much more room creatively. Ad2 was hosting a speaker event about the Science of Branding. Taking the theme of science, the designer researched scientific manuals and illustrations for inspiration. The diagrammatic vernacular that he discovered was used as the foundation for the invitation design. Cool blues and black alongside graphic shapes and lines were used to create a clinical look, with the event information weaved into the scientific diagram. The second invitation continued the scientific theme for an evening for advertising professionals to socialize and share ideas, hosted at a local bar. The designer felt that, aside from the advertising banter, the evening's main focus would be drinking. With this in mind, he developed the concept of a hangover cure as the message of the invitation. He was drawn to pharmaceutical illustrations and packaging from which he developed a pastiche of the aesthetic and language.

A local print company called One Source donated the printing, although they predetermined the paper stock and size based on what they had at the press. The printer reduced his costs and tightened the turnaround time by taking the artwork directly from digital files to press, avoiding producing films and plates.

Above
At first glance this looks like packaging for a pharmaceutical product. On closer inspection it is, in fact, a pastiche of the recognizable look of an invitation to an advertising industry social event.

Opposite
The design of the postcard-sized invitation was inspired by scientific diagrams. The cool blue color and restrained typography create a very clinical look.

> run sequence /
> go to /

> automate identity.brand systems /
> error /
> identity.branding.systems non-automatic /

> >
> INTERNET BRAND:NG

| Ad 2 LUNCHEON | TUESDAY | FEB: 6TH |

@ 11:30 AM

> make impression /
> consumer recognition /

> (1) /

> (1.a) /

> possible brand characteristic

> pulse point /

> integrate strategy /

> anticipate market movement /
> market multi-lateral /
> post results /

Project
hours

Client
Self-promotion

Art Direction
Roger Fawcett-Tang

Design
Roger Fawcett-Tang

Illustration/Artwork
Sanne Tang

Copy Writing
Roger Fawcett-Tang

Reprographics
Struktur Design

Printing
Balding and Mansell

Print Run
500

Dimensions
5.8" x 4.125"
14.8 cm x 10.5 cm

Typeface
Berthold Imago

Colors
Text sections:
four-color process
Cover:
Pantone 452 and 239

Materials
Storafine

Special Process
Double-hinged
cover bound with
an elastic band

For the past six years, Struktur has been playing around with the idea of time-based sequences. This has manifested into a series of self-promotional calendars looking at the underlying rhythms generated by these numbers. The designer has also become increasingly interested in the work of Roman Opalka, the Polish conceptual artist.

The book, *hours*, is a beautifully simple and elegant exploration of the calendar format. Each page feels handcrafted and the A6-sized dual booklets have a very precious quality to them. The single cover cleverly weaves around each booklet, which are ingeniously bound using one rubber band creating a single book. While the first booklet is beautiful in its restraint, the second is in its expression. The designer has chosen to use full-bleed images of his wife's abstract paintings.

As this was a self-promotional piece, the budget was to be as tight as possible. Struktur founder and designer Roger

Fawcett-Tang looked at different binding techniques and formats to help keep to budget. Additionally, he based the size of the book on getting all of the pages for both 32-page booklets out of one sheet. The binding system developed as a result of the budget. Originally the designer wanted to bind the two books as sewn sections, but the cost of the binding alone would have doubled the overall print budget. After considering other various options, the rubber band binding method seemed to work on both aesthetic and budgetary levels. Fenner Paper in the United Kingdom helped find a high quality but affordable stock.

Rather than have the printer do the finishing on the books, which would have increased costs, the designer asked that the work be delivered as two separate booklets and the covers, which were creased but left flat. The laborious task of individually folding and binding each brochure was then left to the designer and his wife, making for a truly personal piece of design.

Opposite
Each book was supplied printed, cut, and creased. The designer and his wife then spent many late evenings hand-finishing each book themselves to reduce costs.

The care and attention lavished on the book is apparent on each page. The paper stock and the print, although created on a budget, were not compromised. Instead, the open-mindedness of the designer allowed for simple and clever solutions.

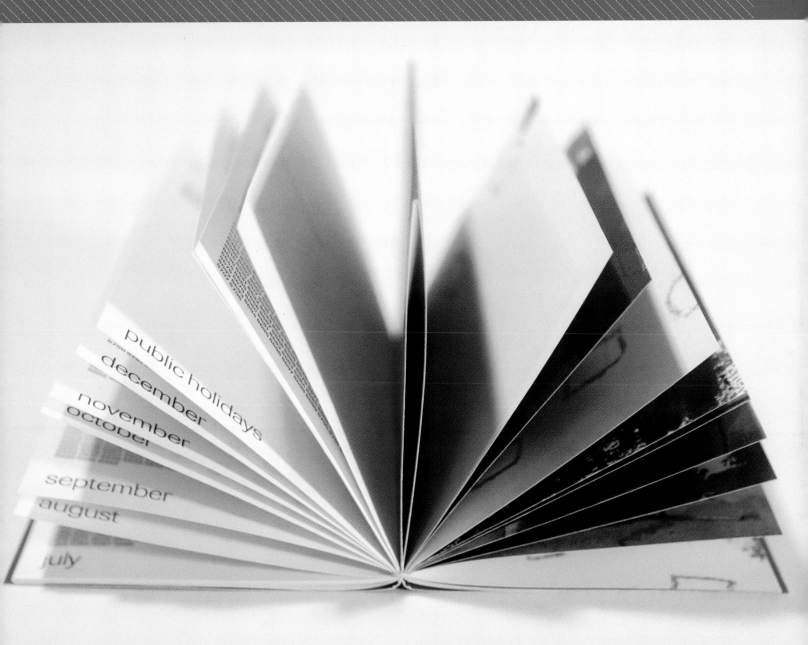

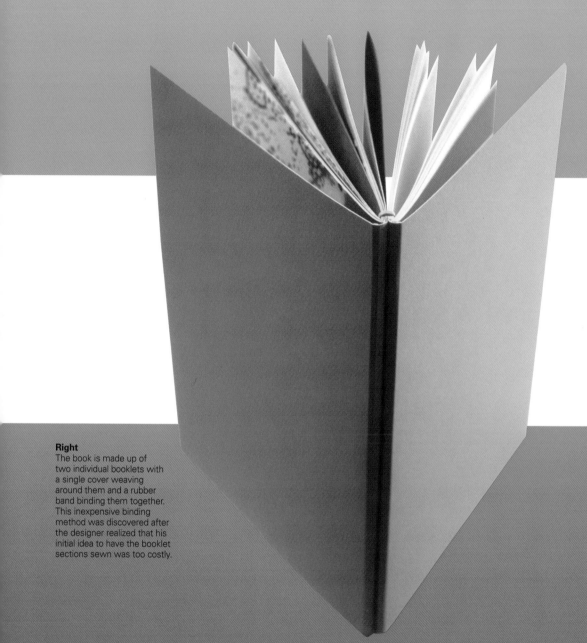

Right
The book is made up of
two individual booklets with
a single cover weaving
around them and a rubber
band binding them together.
This inexpensive binding
method was discovered after
the designer realized that his
initial idea to have the booklet
sections sewn was too costly.

Opposite
The designer's self-promotional
pieces feature his wife's
paintings. These are some of
the beautifully abstract images
found within the second part of
the book.

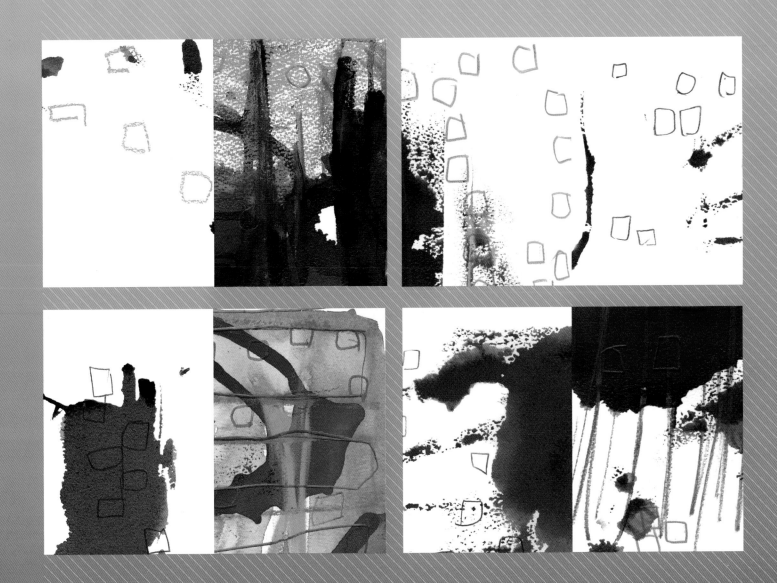

Project
Inside

Client
Bartlett and Associates

Art Direction
Diti Katona

Design
Diti Katona

Illustration/Artwork
Concrete

Length
32 pages

Typeface
Interstate

Colors
Pantone Black,
Pantone Red

Materials
Mohawk Superfine, vellum

Special Processes
French folding, debossing

The interior design firm Bartlett and Associates had a strong reputation for producing intelligent design with an attention to detail. However, most of their experience was in corporate work. They believed the things that made them successful in this field could be easily transferred to other types of work, such as retail and hospitality. Concrete was commissioned to develop a creative solution that would communicate Bartlett's strengths. A photographic representation of their work did not seem appropriate. Additionally, it would be a costly approach for the small firm. Concrete chose instead to create a piece that emphasized the qualities of their work. The result was a vibrant 32-page booklet, using only two colors, that described the qualities of the firm.

Each spread uses a simple sentence accompanied by a symbolic illustration or diagram. The rhythm of the full-bleed red pages and the white pages with the single sentence almost creates the feeling that the white of the page is, itself, a third color. By choosing to use only two colors and not doing an expensive photo shoot, the designers were able to afford other production techniques. These elements were chosen to convey a sense of attention to detail: a debossed dust jacket; luxurious uncoated paper; an introductory page on vellum; and doubled French-folded pages.

Although they were working with limited funds, the designers felt that the communications objectives, more than the budget, dictated a simpler approach.

Opposite
The cover of the brochure is a pure and vibrant spot red with only the word "Inside" set to the left, tempting the curiosity of the reader.

Right
A simple and intelligently playful illustration and a short statement about Bartlett define each spread. The flow of the red and white pages, creating a vibrant tonality while bringing attention to certain details and statements, dictates the rhythm of the book.

Project
Insight: Media Art from
the Middle of Europe

Client
Nina Czegledy,
gallery curator

Art Direction
John Pylapczak, Diti Katona

Design
John Pylapczak, Diti Katona

Photography
Screen captures from
video provided by client

Copy Writing
Nina Czegledy

Printing
Lithography

Print Run
5,000

Typeface
Interstate

Colors
Pantone Black,
Pantone 5777, muted green

Materials
Inexpensive paper
found at the print press

Dimensions
4.75" x 8"
12 cm x 20.5 cm

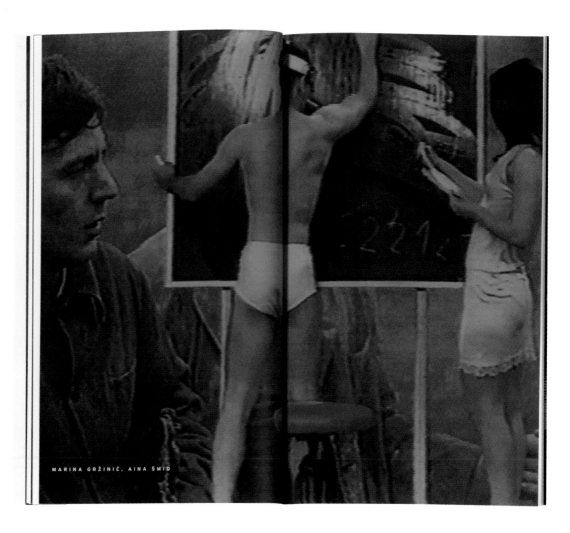

MARINA GRŽINIĆ, AINA ŠMID

Concrete was asked to design a catalog for a gallery exhibit of experimental video art from Eastern European countries, including Slovenia, Romania, Poland, and Hungary. The catalog would be accompanied by a videocassette of the show. In this case, the project had a limited budget, and even the images that were provided were low-resolution video captures.

Concrete's solution was to design a small-format booklet, the size of a videocassette, that relied heavily on typographic design to convey the atmosphere of the show. They used pages with aggressive type—large, densely set Interstate throughout. Using only two colors on white stock enhanced this bold execution. The catalog is printed using black and a muted green color that was specifically chosen to avoid any obvious associations to the communist red. Whereas most of the catalog is typographically driven, the low-resolution images were used in a dramatic way, punctuating the text pages. Rather than shrinking the images to increase their resolution, they are boldly displayed as full-bleed spreads in black and white with the muted green color laid over the top of them.

PROGRAM DESCRIPTIONS

ANDRÁS **SÓLYOM**
HUNGARY

FUNERAL, 1992 7:00
The spectacle of the mythical communist state funeral is juxtaposed with the chant of a surrealistic poem by Akos Szilagyi.

MARINA **GRŽINIĆ** AINA **ŠMID**
SLOVENIA

LUNA 10, 1994 10:35
Luna 10 is a contemplation of the role of media in the Bosnian war at the time of Internet communication and worldwide computer webs. Inserts from Yugoslav neo-avant-garde films from the seventies are coded into this video.

PÉTER **FORGÁCS**
HUNGARY

WITTGENSTEIN TRACTATUS (EXCERPTS), 1992 10:00
Based on selected writings of Wittgenstein and using images from his Private Hungary archives, Forgács produced seven intricately layered, contemplative five-minute segments, two of which are included in this program.

JASNA **HRIBERNIK**
SLOVENIA

BALLABENDE, 1995 21:47
The old house embodies and preserves the beauty and attraction of the earlier times. The space reveals a terminal condition: demolition. The deformed vision of a historic moment is just an easy decoration on individual consciousness, robbed of "Ballabende" (evening balls).

ANDRÁS **SALAMON**
HUNGARY

GYPSY BALLAD, 1992 5:00
An old woman and her son living in a shack. "I have never witnessed such desperation before. With hesitation I lifted the camera. This expensive piece of metal seemed absurd in this environment. The man and his mother watched me in terror. I put the camera down and started talking to them. We are just making a movie, I said."

NATAŠA **PROSENC**
SLOVENIA

DISK (DISCUS), 1995 10:00
Leadership – the leading of masses – is a trauma rooted in the psyche of people living in post-communist societies. How free are our decisions and whose marionettes are we? are questions of universal significance. The floating discus – the invisible God, changeable like a chameleon – is leading masses of a different kind.

MAGDA **KUBINYI**
HUNGARY

TRANSPARENCY, 1994 1:00
Deconstructed surreal images appear briefly in this intriguing video étude by a student of the Hungarian Academy of Applied Arts.

50

51

Opposite
The typography creates the overriding structure of the design. The Interstate typeface is bold and has a functional and solid character, which is enhanced by the use of black and muted green.

Rather than reshooting the photography, the designers decided to use the supplied low-resolution imagery. This is put to dramatic use as full-bleed images that punctuate the typographic spreads and create a unique texture, which is a product of their low-resolution quality.

Above
Large, justified text dominates many of the spreads and creates a bold graphic language that complements the tone of the exhibit.

Right
The catalog format was chosen to be the same size as that of the videocassette it was to accompany.

Project
Call for Entries

Client
Advertising and Design
Club of Canada (ADCC)

Art Direction
John Pylapczak, Diti Katona

Design
John Pylapczak,
Theresa Kwon

Illustration/Artwork
John Pylapczak

Copy Writing
John Pylapczak, Steven Blair

Printing
Lithography

Print Run
5,000

Typeface
Interstate

Colors
Pantone 186 and grey

Materials
40 lb. Glacier Opaque

Dimensions
22" x 32"
56 cm x 81.5 cm

DIRECTIONS 2001 To encourage and promote the highest professional standards, The Advertising & Design Club of Canada's annual show and awards presentation salutes the best of this year's creative work, selected by an internationally recognized jury of experienced judges. Winning work is displayed at the show and also published in the awards annual as a permanent record. Gold and silver medal selections will become part of the collection of the Royal Ontario Museum. The deadline for entries is 5:00 p.m., May 7, 2001.

Concrete was commissioned to develop a call for entries for the Advertising and Design Club of Canada (ADCC). The challenge with this—as with any other call for entries—was to do something that would capture the attention of an audience that is inundated with this kind of material. Many calls for entries tend to be gimmicky, overproduced, and overtly clever.

In this case, as in many other collaborations with a design institution, the club had limited funding so the entire production had to be donated. However, it is not necessarily seen as "design for free" because such institutions are there to represent the design community, nurturing both sharing and discussion. Designers chosen to work with these institutions generally see it as a privilege and an acknowledgement of their achievements. With this in mind there is

a mutual understanding between institution and designer allowing for more creative freedom.

For this particular call for entries, Concrete's solution was a rant on the state of the industry. The text, which is the star of the piece, is a commentary on the lost art in our business. It maintains that it is the art, not the strategic legitimization, that makes what we do important, vital, and successful.

Both the design and the form are pared down and simple. Graphically, they used a crude profile of a head to carry the message, while the reverse conveyed all the information, including the entry forms. The two-sided poster was printed on inexpensive paper in two colors. The simplicity and reduced nature of the design made the message appear the more important element.

Right
The designers intentionally chose to use only two colors. The graphic simplicity of the design invites the recipient to read the copy, giving the message more importance than the design.

Opposite
The reverse of the two-sided poster is purely typographic. The structured layout breaks down the information into its key components, with the larger text providing the overview whereas the smaller text provides the details.

AT THE HEART OF ANY
DESIGN SHOULD BE AN
IDEA. BE VERY CLEAR
ON WHAT THE IDEA IS,
AND ONLY THEN FIND
THE WAYS THAT WILL
BRING THIS ALIVE.

On a budget, they said. Unpaid, they meant. But the chance to tell you my side of the story. You see, I'm not a designer. I'm a suit, a planner, a catalyst for making things happen. Someone smarter than me once described my role as a conductor—making the most out of the resources at hand. No pitiful metaphors about sweet music.

So what can I tell you about graphics on a budget? Well, it's harder, or easier, depending upon which path you take. And one way can be much, much more rewarding. I fundamentally believe that the size of the budget should be irrelevant to the quality of the work, it's just that, unfortunately, that's often how things work out. Yes, there will be limitations of execution—that hand-drawn typeface or the eight-color special print with the never-seen-before foil embossing might have to wait. But too often a richness of budget can mask the reality that there isn't actually any idea there—a papering over of the cracks (with a very heavyweight, handwoven stock). So what should we think about when confronted with a brief with a limited budget?

Focus
Really understand what the brand represents, what is at its core. To be honest, that much should come with the brief, but if it doesn't, ask. Probe, work out, assume. And check with the client. Otherwise, you'll use those precious limited resources of time (and money) bravely forging in one direction, while the client is thinking of a different destination. What does the brand stand for? What is its personality? How does it make consumers feel? The rational, product-led attributes will change

tomorrow, or the day after, and they've probably already been copied by the competition. But dig deep into the emotional characteristics of the brand, because that is the clearest point of differentiation. The brand is the promise that consumers buy, and that's what your task is—to bring the brand alive.

Clarity
At the heart of any design should be an idea. Be very clear on what the idea is, and only then find the ways that will bring this alive. Tell it to me—put the idea into one sentence. And then show me your talent to articulate the idea in design. Often it's the small touches, the attention to detail, that can be lost in the magnitude of a large budget.

Intuition
Time is not necessarily eroded with a limited budget. But paid time is. This means that we need to trust our instincts a lot more. Commissioned research, a wealth of factually based, proven knowledge is probably not possible. But don't just wing it—challenge yourselves. Am I doing this just because I like it, or am I doing it because the audience will? Put yourself in their shoes. And that needn't take money to do so. Spend an hour—go on, commit a whole 60 minutes testing yourself on what your audience does, thinks, feels, tastes, touches, drinks, eats, laughs at, lives…become them. And then look at your idea and see if it will work. Will it deliver that promise to them in the most compelling manner?

Exposure
Then ask them. Go on. Too often we marketing people hide behind our titles

and our workloads and avoid the bare reality of actually meeting the people we are trying to stir. It's surprisingly easy. And hard. Don't worry about having to do it in a statistically proven, professional manner. Great if you can, but if not, just make the personal commitment. Spend a little extra time to actually chat with them, watch them, ask them. Too often we hide—and I think that's because we all fear rejection. Bare yourself. You'll learn.

Honesty
Successful brands today are not necessarily the ones with the most money. They are the most honest brands —the ones that understand what they are and, most importantly, are clear about that with their audience. Consumers today, "prosumers," are professionals at marketing. They are brand savvy; they know what you are trying to get them to do. And if they want to do it, they're happy. But they will reject any falsehood or overpromise, any gilt. Honesty is not limited by budget.

Enjoyment
Have fun. Put a little of yourself into every job, and don't measure that out in dollars, pounds, or euros. Like any relationship, it's what you put in that determines how much you get out. And ultimately, our business is a subjective one. Did they like it, did it move them? So do whatever you can to try and swing it in your favor. Relish the challenge. So that's a few thoughts from a nondesigner. Are these the principles for "great graphics on a budget?" Yes. And no. They're principles for any task on any budget. Or should be.

Project
Consolidated Baily
identity

Client
Consolidated Baily

Design
EGO

Copy Writing
EGO

Left
The Consolidated Baily identity uses an interpretation of the initials CB to create a corporate character. The bear symbol becomes a playful identity system for the entertainment company.

Right
Application to collateral allows the flexibility to change and adapt the facial features of the icons to reflect the personality of the company.

Below right
Initial sketches show the range of direction and graphic interpretation before the final icon was chosen.

Consolidated Baily approached EGO to create an identity system for their new branding and entertainment company. The company was started by Evan Baily, who was a writer and director at Nickelodeon. Consolidated Baily happily works in both entertainment and branding, so the identity had to reflect their unique approach to helping television shows and networks find their voices.

As with most projects, EGO began with an ideation phase that involved a lot of sketching, searching, and brainstorming. The solution evolved into a dynamic logo system based on a character whose facial features were made from the company's initials, CB. A family of characters grew out of this with different add-ons (horns, antennae, ears, hats), and the designers assigned a rainbow color palette. This variety within a controlled system reflected Consolidated Baily's branding expertise within the entertainment industry. Consolidated Baily's combination of no money and close friendship with EGO placed the designers in the rare position of working for reduced rates. Most of their budget was therefore applied to the production of full-color stationery components, including die-cut and double-sided business cards.

Project
"Command O"—*Open*

Client
Self-initiated

**Art Direction,
Design, Photography,
Illustration, Copy Writing**
Billy Davis, Sean Brunson,
Andi McNamara,
Mike Witt, Klaus Heesch,
Larry Moore, Kim Foxbury,
Julio Lima, Thuan Nguyen,
Jamie Bogner, Jeff Matz,
Jane Harrison, Jenise
Oberwetter Davis, Paul
Mastriani, Tom Hope,
Tom Macaluso, Doug
Scaletta, Scott Sugiuchi,
Steve Carsella, Bryan
Kriekard, Thomas Scott

Printing
Oviedo Publishing

Print Run
5,000

Dimensions
10.75" x 16.6"
 27.5 cm x 41.5 cm

40 pages, self-cover

Typefaces
Various

Colors
Black and lime green

Materials
35 lb. newsprint

Special Processes
Saddle stitch

Open is the printed expression of a community of designers known as Eleethax. The group, which exists primarily as an e-mail network of designers based in Orlando, Florida, and two Orlando expatriates in New York City and Baltimore, was initiated in 2001. It is a vehicle for encouraging dialog and collaboration between designers who are geographically close but socially divided. *Open* came about through months of debate and conversation, with each designer weighing in on everything from content and layouts to printing and distribution. Each designer was given a spread and complete, unedited autonomy to create an image centered on one theme. The theme of

this issue, the first of an irregular series, was "Growth"—and, according to the designers, was a subject near and dear to the heart of anyone who has spent time in Orlando.

Budget was a major consideration as this was a self-initiated and self-funded project. Creatively, this set up not only a physical challenge of using two colors, cheap newsprint, and Web printing, but also set an "underdog" tone of the publication. Even so, the team felt that the limited budget and challenges focused and increased the level of creativity to the point that there was a serious discussion of limiting it even further to only one color.

The project took five months to complete with the biggest challenge being the coordination of the 19 contributors across three states. The collaboration created an interesting and dynamic working environment for the designers. The magazine itself felt cohesive even though each spread reflected the aesthetics and personality of each different designer. Although the designers originally chose to use Pantone 390, they discovered that by using the printer's ready-mixed lime green, the cost would be reduced substantially. Five thousand issues of the large-format magazine were produced, which, in hindsight, was felt to be too many for such a niche product.

Left

The entire *Open* magazine is printed on newsprint, which allows the designers to have a large format even with their limited funds. The cover invites the reader to look further, with the well-known computer "Command O" symbol, meaning Open.

Even though each spread is by a different designer, the bold use of black and lime green helps to create a cohesive look throughout the magazine and reduce costs at the same time.

The large format of the magazine gives it a very strong presence, making each spread almost a poster in its own right. This is enhanced by the effective use of color, space, and form in each composition.

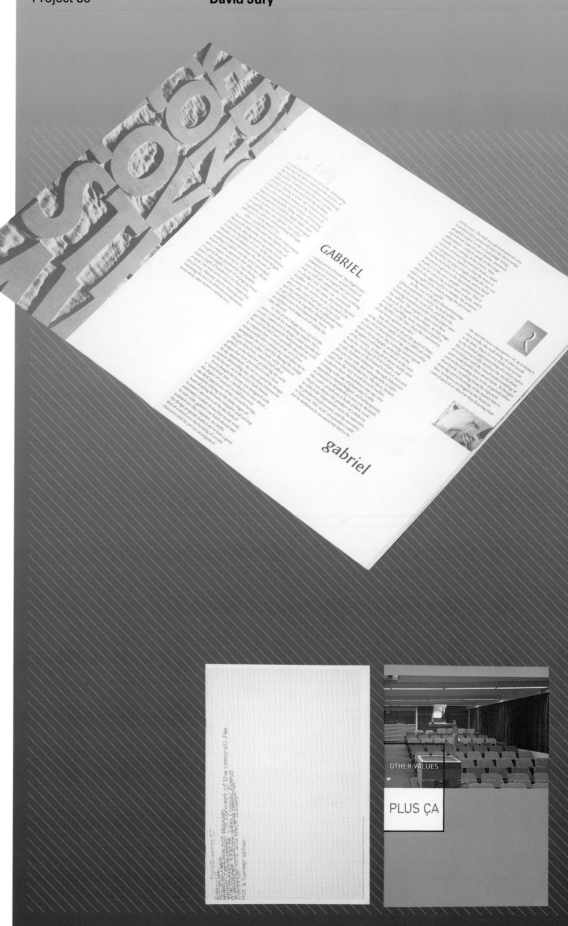

Project 36

David Jury

Project
TypoGraphic

Client
International Society of
Typographic Designers

Art Direction
Various

Design
Various

Dimensions
8.4" x 11.8"
21 cm x 29.7 cm

Typefaces
Various

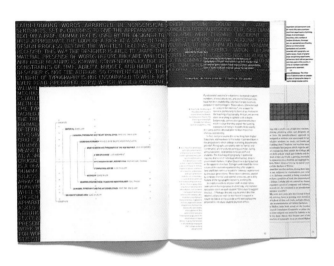

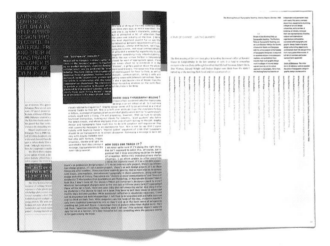

TypoGraphic is the journal of the International Society of Typographic Designers and is published three times per year. Since 1998, when David Jury took over as editor, the design of each issue of the journal has been offered to a different typographer or graphic designer. Designers whose working methodology and design philosophy reflect the theme of that particular issue are invited to participate, which will, directly or indirectly, enhance the written contributions.

The designer has a free hand in exchange for no fee. This is only viable because the readership is, essentially, based within the typographic community, so this commission is generally seen as an opportunity to design something that truly reflects the designer's (as opposed to the client's) concerns. The understanding is that the journal they design is very much their own because the only limits imposed are the

format, which is A4, and the budget. Working with different designers for each issue has another budget advantage in that each has contacts within the print, print finishing, and paper industries. Naturally, designers will often want to use specific materials and processes that they feel are appropriate to their objectives. However, as with all things nonstandard, these tend to be more expensive, so the designer will often call in favors owed to obtain the required results.

Because there is no common template for *TypoGraphic*, each issue presents a completely different set of production problems. This is one of the reasons for the relatively low number of journals produced per year and is certainly the main cause of delays. With the mix of high production values and a minimum budget there is inevitably a struggle, but one that is well worth experiencing to get to the final product.

Left
A different designer or design team is invited to design each issue, creating a blank canvas for the designers to express themselves through the content without the traditional constraints of a typical client project. It provides the rare opportunity to try new ideas that normally would not make it further than the sketchbook, making for a very exciting journey for both David Jury and the designers.

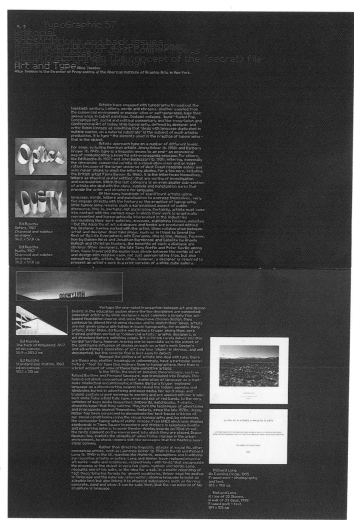

Opposite
This issue, designed by
North, is in landscape format.
Printed on high-gloss paper,
the design is understated and
elegant and uses an intricate
custom-made typeface.
The white spreads are
punctuated by vibrant full-
bleed magenta spreads,
creating a moment of drama.

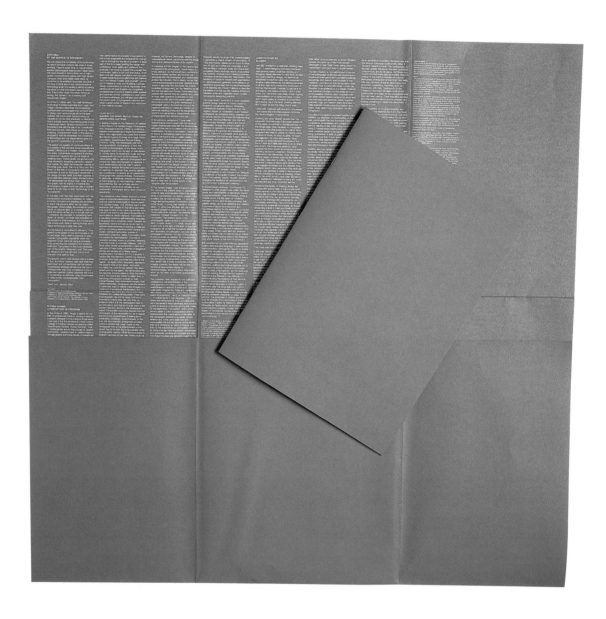

Right
Taking full advantage
of the freedom to
interpret the brief, The
Designers Republic has
created a large-format
one-color poster that
contains all of the text.
It folds down to become
the sleeve of a book.
The book itself has no
copy in it but is a beautiful
and emotive journey
through a spectrum of
custom-made colors.

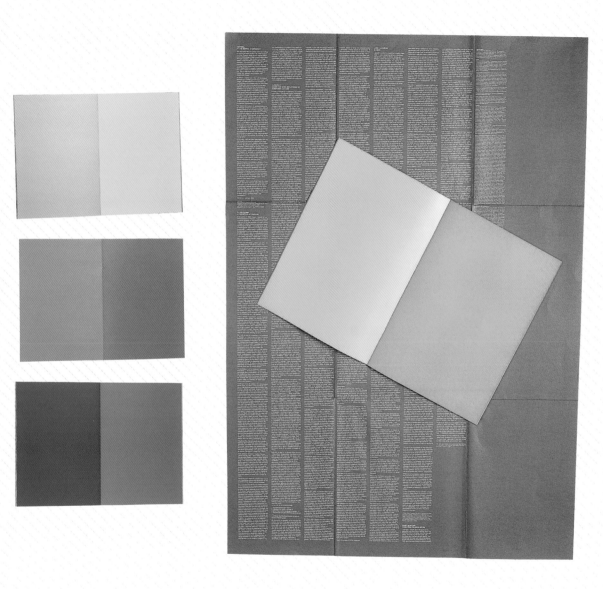

Project
Self-promotion

Client
dixonbaxi

Art Direction
dixonbaxi

Design
dixonbaxi

Photography
dixonbaxi

Copy Writing
dixonbaxi

Printing
Black and white laser printer

Dimensions
Sheets:
8.4" x 11.8"
21 cm x 29.7 cm

Freezer bags:
8.4" x 16.5"
29.7 cm x 42 cm

Typefaces
Din Regular,
Din Bold, Bauer Bodoni

Color
Black

Materials
80 gsm pink photocopy paper
Preprinted clear
plastic freezer bags

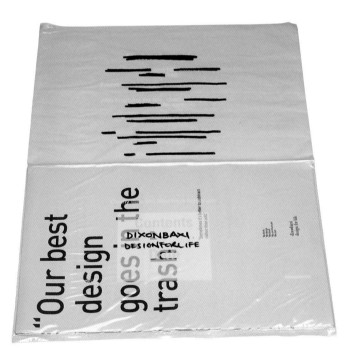

Like many design firms, dixonbaxi wanted to develop a simple means to effectively communicate what it does and show some of its work when mailing potential new clients. Clients get numerous packages from designers and have little time to look at them, so they often end up in a pile somewhere. Most of them look the same, too, arriving in generic FedEx boxes or padded envelopes. The designers wanted to avoid having their package get lost in the shuffle, so they set out to create something intriguing enough to warrant clients' attention.

Having been successful in creating memorable work for their clients, the designers felt that it was time to apply the same thinking to their own packaging. With a very small budget, dixonbaxi decided to use found materials as opposed to printing or manufacturing anything new. Using regular pink 80 gsm photocopy paper, the designers output simple but thought-provoking statements

about their way of working using their black-and-white laser printer. Alongside the typographic statements were a series of sheets featuring their work. These were shot using a digital camera and then printed on the same pink stock using the laser printer. Rather than using standard envelopes, dixonbaxi found some inexpensive, plastic freezer bags that were exactly the right size to accommodate the A4 sheets. The bags were preprinted with text related to freezing food. This led to the designers using a black marker to strike through certain parts of each sentence, essentially creating new sentences that related to the actual contents and personalizing the bags.

The plastic bags were filled with the set of laser-printed sheets and hand-sealed with low-tack glue. The aesthetic and conceptual tone of the package was enhanced, rather than compromised even though the materials were everyday items and very affordable.

Opposite
If the designers were to commission the fabrication of these plastic sleeves, it would cost substantially more than buying freezer bags from a supermarket. Making a virtue out of the budget led to an inventive and clever solution of customizing the preprinted bags. Had the budget for plastic bags been available, this solution may not even have been considered.

Left
A black indelible marker has been used to strike through the preprinted text on the freezer bag, creating what appears to be a series of strange horizontal markings. On closer inspection, one can see that the text has been edited to create new sentences relevant to the content.

Project
Font kit bags

Client
[T-26] Digital Type Foundry

Design
Carlos Segura,
Tnop Leeyavanich,
Akarit Leeyavanich,
and many others

Printing
Burlap bags:
SOB Rohner Letterpress

Print Run
40,000

Dimensions
9" x 12"
23 cm x 30.5 cm

Color
One Pantone color,
different for each edition
of the bag

This spread
Each [T-26] Font Kit is a
limited edition gift that is
mailed to over 35,000
designers worldwide.
The design firm searched
long and hard for a cost-
effective packaging solution
and settled upon a burlap
bag. The content of each
bag is a cornucopia of
typographical experiments
using numerous processes
and materials. Even so,
it is successfully created
on a very lean budget.

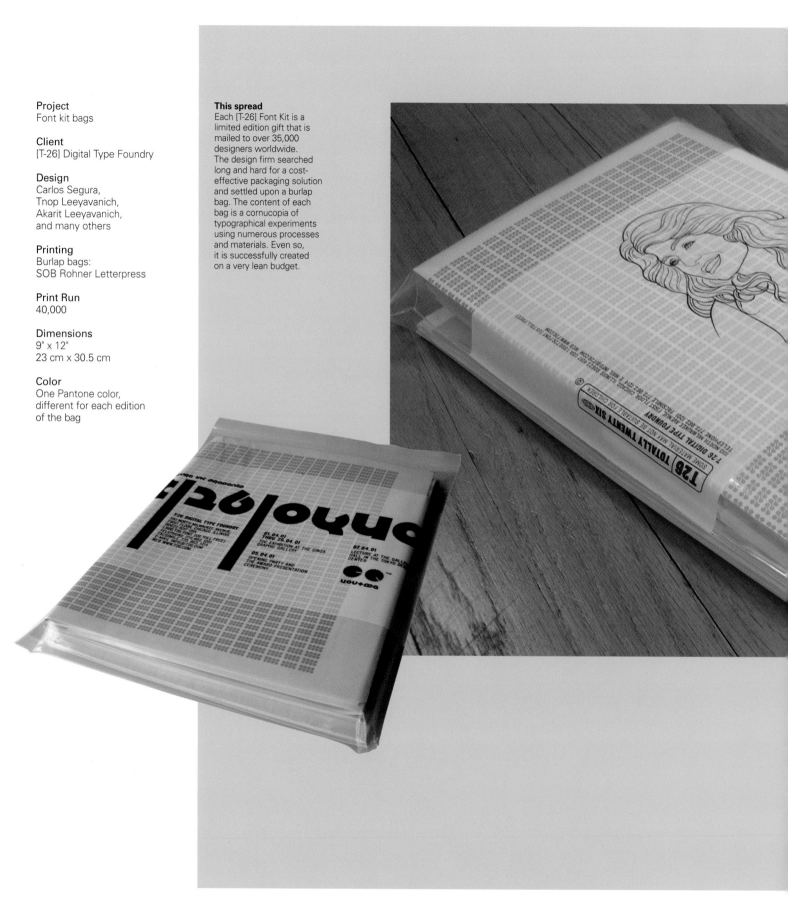

Chicago-based Segura Inc. wanted to develop a way to advertise their [T-26] type foundry and its huge catalog of fonts, while avoiding traditional marketing techniques. Their ideas crystallized in the form of a package that was more personal gift than marketing tool. The result is a limited edition font kit that is sent out to the firm's mailing list of over 35,000. Each free font kit arrives in a single-color screen-printed burlap bag and is packed full of silk-screened, hand-painted, sheet-fed, linoleum-cut, letterpressed type design experiments on a variety of substrates including napkins, posters, and newspapers.

The font kits are produced at least two times per year and are limited editions; once one batch runs out it is never printed again. The designers then move on and create entirely new work. Although this might sound like a very costly exercise, the project is far from it. The designers spent a long time researching to find a packaging format that was both cost-effective and could accommodate the differing densities of content. They found U-Line, a company that could custom-make the burlap bags. They chose burlap over plastic as it was much cheaper to silk-screen onto. The bags have grown

to become a well-known design icon representing [T-26] in the mind of the design community.

The project is a labor of love for the company with each experimental piece of content created by hand or through bartering with a vendor to keep costs to a minimum. Even with the budget restraints, there is still plenty of room for the design team to create some great work. The product's quality and limited-status, one-off approach makes each item collectible and far from a budget feel.

One example of the design firm's diverse use of processes is the dying art of letterpress. They first tried setting metal type, but this proved too costly and time-consuming. They were forced to look for another technique and discovered a process that allowed them to create the artwork on a computer and then output a film. From the film they would fabricate a polymer plate, which is a plastic sheet with the raised artwork on it. This would then be used in the same way as metal type and printed to capture the unique qualities of letterpress. By finding a new method they were able to practice a lost art while working to a very tight budget.

Project
[T-26] newspaper campaign

Client
[T-26] Digital Type Foundry

Design
Segura Inc.

Illustrations
Segura Inc.

Printing
Rippon Printers

Print Run
50,000

Dimensions
Folded:
9" x 12"
23 cm x 30.5 cm

Open:
9" x 18"
23 cm x 45.5 cm

Typefaces
Various featured

Color
Two-color, Pantones,
different for each edition

Materials
White offset

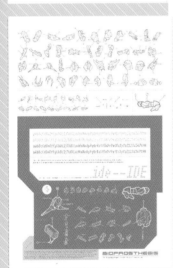

For the last two years, Segura Inc. has been producing the very successful [T-26] newspaper campaign as a means of exhibiting special font collections. The bimonthly edition offers specific bundles that are edited into themed sets of typefaces relating to a particular design execution. For example, the D-Set consists of text faces suitable for books, magazines, and anywhere that a designer needs a lot of copy, whereas Identical is a contemporary range for record sleeves, CDs, and book covers.

The designers felt that sourcing cost-effective printing was key to the feasibility of the campaign. Although they wanted to explore the least expensive method, they did not want the newspaper to feel cheap. They spent four months looking for the right printer and found Rippon Printers in Wisconsin. Rippon Printers had a huge factory that specialized in Web printing, traditionally used for huge print runs. Using a Web press as opposed to a traditional sheet-fed printer saved the team money and allowed them to upgrade to a better quality stock, increasing the quality of print achieved. The newspaper itself was restricted to using two colors, although these change with each edition. The designers were cost-conscious at every turn, even down to making sure the design was specific to the U.S. Postal Service specifications. A simple oversight of placing the address in the wrong place could have increased mailing costs dramatically. On a mailing list of over 50,000, these costs would have become prohibitive. By doing their homework and making sure that each avenue was carefully researched, Segura Inc. was able to successfully create a viable and creatively experimental publication.

Opposite
Each edition of the newspaper is created using two colors with the design following a particular theme. It is a playground for the designers to create experimental work while displaying font bundles that are offered at reduced prices.

Left
Segura Inc. spent a long time researching many cost-cutting ways to make the project a viable reality. Using two colors, sourcing a Web printer rather than a sheet-fed printer, and paying attention to details such as U.S. Postal Service specifications have all helped in achieving this goal.

The Three Rules for Great Copy
by Martin Hennessey,
Creative Director and Founder,
the writer Ltd

OK, So the Set Up Is This...

You've just won your absolute dream design project. Your client has been sent from heaven. They have given you total creative freedom. They say to you: "Take us, designer, to wherever you want us to go. Take our project and make it yours. Take our commercial goal and fill it with all the creative juice you've got." There's only one drawback. You've got next to no cash to do it. That's when you need a writer. "But writing is expensive," you cry. Only when it goes wrong.

So here they are, the three rules that we at thewriter.co.uk can guarantee will turn your design project into gold. And first, whatever the project, whatever the package, Web site, video box script, or sneaker label, there's only ever one place to start, just as you would for any story—from *Fargo* and *Hamlet* to Nike commercials and Cinderella—and that is at the end.

Rule One: Start at the End

Where Are You Going?

So trite and yet so true. Always, always know exactly where you're heading. That means locking down the commercial or creative objective you are aiming for, and it means having a plan—not for the words (at least not yet) but for the project as a whole. And to really save money the designer's plan must include the following (in no particular order):

Know Your Audience

Know your audience. If you know what they like visually, then you're more than halfway to knowing what language they already use. What magazines do they read? What television programs? More than anything you need to know what language they use. It's obvious with a young audience—because their language is often already shared by designers. But what about an older audience? Or a technical one? The basics are always the same: find out how your audience speaks.

What's Your Pitch?

Starting at the end also means knowing the top-line messages and "unique selling point" of your product or service. Do not leave this to a writer. This is your job. It's your client. So agree to a list of three (why is anything more than three forgotten?) benefits or features to include—then look for ways of repeating those qualities whenever you can.

Less Is More (Obviously)

Do not be fooled into including loads of words. Try this exercise for yourself: how many words are there in Nike's "Just do it" (Three? Now, there's a coincidence). How much do those three words speak about the product and its relationship to the reader?

Think Story

We've got a theory at thewriter.co.uk. The best commercial writers in any company are the people who sell the product or service. They're the company's most natural storytellers. So we always head to the sales team first. They'll know the customers' fears and their dreams. They'll know which buttons they've got to push. So talk to them about the top three messages you need to convey and ask them what their most successful "pitch" is to a customer.

Seek Out Emotion

Many design projects fail by stripping emotion from the words they use. Remember, you're trying to engage with real people and real people have feelings. So go look for them. Find out what will make your clients smile or, on occasion, what'll make them afraid. Then discuss emotional triggers with your client. Only once you've lavished all this thought and attention on the ending are you really in a position to understand the value of rule two.

Rule Two: Find a Writer You Like

Sounds obvious, but if you're designing on a budget then you absolutely cannot afford mistakes and misunderstandings. Do not waste time and money on a writer you don't get along with.

Who to Avoid
Be very aware that many writers overclaim. Do not be fooled by experienced copy writers who claim they can turn their hand to any writing. They're the hacks. A good early warning sign of hackery is those who claim they can write "fast, accurate copy." For "fast" read "those who churn out copy." And for "accurate" read "those who won't add anything of their own."

Get 'em in Early
Obviously the best writers can do all the thinking for you. However, if you're designing on a budget you'll need to do as much work as you can. But either way you want to get the writer involved as early as possible. Sit down with them. Get them involved.

What's in It For Them?
One good secret to know about writers is this: the really good ones charge less for interesting work. So if the job's a nice one and you're making them feel valued and involved, then your writer will almost certainly be willing to take a lower price. And if you're creating something really, really cool together—something that could help them build a reputation or could help them win new work—then you may even be able to persuade them to do it for free. (For pete's sake, don't tell them I said that.)

Creating a Brief
A brief is really a very simple thing to write. (You can even download ours from our Web site.) It's not about being creative or clever. It's simply about being clear and simple.

Draw Up a List of Copy You Need
Dead easy, this. What media is this project? Web, print packaging, film, sneaker label, or whatever. What space or pages do you have to fill—even approximate word counts will help enormously here.

What Factual Content Must Be Included?
This is something for the client to give you. Remind them you're not producing a book (unless you're producing a book, that is). List facts and details for the copy to include. And this takes us to the final and ultimately most important rule of using writing to add that magic to your design projects on a budget.

Rule Three: Write Everything Down

Avoid Misunderstandings
This is incredibly important if you're going to keep your costs to a minimum. Most misunderstandings about copy are caused by conversations. You think you've been clear in a meeting, and the writer thinks they understand what you meant. It's amazing but that often isn't enough. It doesn't matter whether you type your comments into the document or you scribble all over it. Pick out the words you like. Highlight those you don't. The point is, write it down. There is only one way to avoid these misunderstandings. By committing your reaction to copy and ideas on paper, and discussing them with the writer.

I think that's it. Our three rules to getting the ultimate value from writers. Start at the end. Pick a writer you like. Write everything down.

Project
Greenhood and
Company stationery

Client
Greenhood and Company

Design
Vrontikis Design

Rubber Stamp
Stamp, Stamp, Stamp

Paper
French Paper Company's
Construction

The Vrontikis Design studio needed more sophisticated computer networking and archiving systems that they couldn't afford. Robert Greenhood, an IT specialist, needed business correspondence materials he couldn't afford. Bartering seemed like a mutually beneficial idea to overcome these obstacles.

Lack of money was the overriding inspiration for the Greenhood and Company stationery system. In this case, as in others, when Vrontikis Design is confronted with major limitations such as no budget, they try to connect the dots to see if, indeed, a solution can be found in the problem.

Approaching these situations with a sense of humor instead of frustration opens up their creative thinking to nontraditional solutions. Robert Greenhood mentioned he needed maybe 300

letterhead sheets in a year. Offset lithography wasn't ideal, so the designers found a low-cost alternative with rubber stamps and black laser printing. Greenhood also mentioned his appreciation for Russian Constructivism. Accordingly, the design team used this inspiration and selected French Paper Company's Construction line as the perfect palette to reflect the design. The process then became about using man-hours, and Robert Greenhood's new assistants found time to rubber-stamp each individual letterhead by hand.

An unexpected result was that this stationery system has won more awards than any other of the very elaborate and expensive stationery sets Vrontikis Design has completed. This innovative solution was appreciated purely on a design level by competition judges.

This page
This design harks back to the strength of the Russian Constructivist movement with the freedom of contemporary American typography. The stationery benefits from hand-finished stamping, which adds a crafted feel.

GREENHOOD
+ COMPANY

11718 Barrington Court Suite 122 Los Angeles, California 90049 PHONE 310.203.4993 FAX 310.476.6406 E-MAIL robert@greenhood.com

NEW MEDIA & TECHNOLOGY

Project
Phojekt.com

Client
Self-promotion

Design
Ash Bolland

Photography
Ash Bolland

Copy Writing
Ash Bolland

Colors
RGB

This spread
onemorethantwo has an expressive and experimental take on design. Blurring the boundaries between design, typography, illustration, and 3-D rendering, these self-initiated images are definitely part of contemporary online culture. Using technology in a very direct and spontaneous way creates images of instant visual impact.

MAN MADE
I HOPE IN THE FUTURE I USE MY
AND MY MIND - AS I DONT LIKE T
COMPUTER BODY VERY MUCH

As a self-taught designer, it is very important for Ash Bolland, who runs onemorethantwo with von Dekker of redchopstick.com, to have a place to learn. He has, in a sense, developed what he calls his own design school. Phojekt.com is used to help his understanding of the design process and new technology and for creating ideas. It is a chance for the designer to explore, without commercial constraints, through a virtual sketchbook, which has developed into a library of text and imagery. Certain ideas from this ongoing development are used to inspire and inform the designer's commercial work. Not only has it become a portfolio to show clients, but, perhaps more important, it has also developed into a way of discussing new and interesting approaches to commercial projects. Working purely within the interactive and digital environment has allowed the designer a huge amount of creative freedom without the production limitations that a print budget can impose. Most of the work is designed on the screen, for the screen.

However, before any work is done on the computer, the designer spends a lot of time initially writing words and thoughts that he wants to explore. His research then turns into taking photos that capture the essence of these ideas before he begins to design.

Although dense, lavishly detailed, three-dimensional environments are becoming a shared vernacular within the interactive design domain, the designer puts his own spin on the theme. Also, the Web allows many more people than would see a printed poster to be exposed to his work. Besides the cost of hosting the site, it is essentially free to produce, so the designer's work is always changing and developing and is on his site for all to see. Like many other such sites, it becomes an audiovisual diary of the designer's growth and development. The beauty of the Web is that it breaks down any communication barrier, allowing anyone the chance to share the experience.

Project
Personal portfolio

Client
Self-initiated

Design
Eduardo Recife at
Misprinted Type

Specifications
"determinism":
7.5" x 7.25"
19.2 cm x 18.2 cm

"true love":
8.4" x 11.8"
21 cm x 29.7 cm

"happiness":
11" x 8.5"
27.9 cm x 21.5 cm

"flores":
4" x 6.1"
10 cm x 15.4 cm

Right
An unreleased self-promotional
poster, "flores" uses an image
taken by the designer with a
35-mm camera, developed in
a one-hour photo booth, and
scanned on a desktop scanner
in the designer's studio. It was
then manipulated and enhanced
in PhotoShop and blended with
the typography.

Opposite top
"happiness" is an unreleased
double-page spread created for
a black-and-white experimental
print magazine. As it was for an
underground magazine, the
budget was low and meant the
designer needed to use found
vernacular to create the piece—
a collage using cut magazine
images, pencil, and distressed
paper. The monochrome color
scheme was turned to an
advantage with a darkly textural
image and typographic layout.

DO NOT TRUST THAT. ONLY BLIND PEOPLE ARE HAPPY

Based in Brazil, Eduardo Recife is an industrious and eclectic designer. Money has never been an issue for his creativity. As with many artists, he has created beautiful work with just a pencil and paper. When he works for a client who has little money to spend, he doesn't panic.

Eduardo has a huge collection of vintage magazine pages, photos, objects and papers he finds in the streets, old stamps, instruction books, pieces of rusted metals, and countless pieces of strange printed material. Using it as a creative source book, he can dip in and out of his collection to create beautifully crafted design with little or no restriction from budgets. With the almost infinite number of free resources in his collection, he continually explores how they can be used for just the right project. His experimental images created with no budget other than his personal time are not commercial pieces, but inform the magazine spreads, music albums, posters, and other designs he creates. If he doesn't have money to spend on a photographer, he'll take the shot himself. There is beauty in amateurish photos that even some professionals can't achieve with their $6,000 cameras. The secret, he finds, is to collect and create a variety of materials that one day could be useful for his work. An old piece of paper that you find on the street could be one of these elements. He trusts that he has the right eye for the right things and, later, for the right project.

Above
This collage is a project called "determinism," and it uses an old notebook cover and vintage magazine advertisement image. The text and textural elements were added in PhotoShop.

Above
A collage titled "true love" uses old vintage magazine cuttings and found material reworked in PhotoShop.

Project
RayGun

Client
RayGun magazine

Art Direction
Barry Deck

Design
Barry Deck

Photography
Various contributors

Illustration/Artwork
Various contributors

Copy Writing
Various contributors

Typeface
Eunuverse

Colors
CMYK

Right
The cover of then newly
designed *RayGun* magazine
featured a proprietary typeface
designed specifically for the
relaunch. Eunuverse, a
synthesis of typefaces
Eunnuch and Univers, was
used throughout each issue.

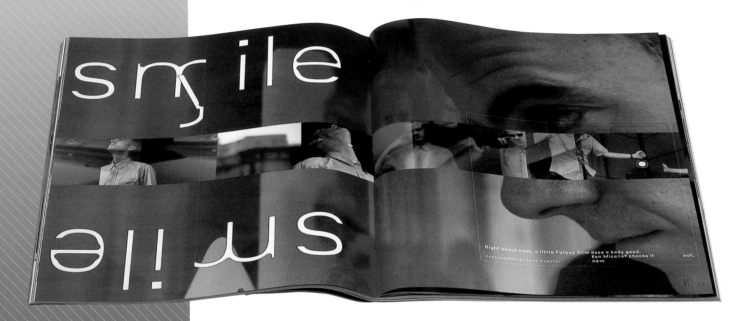

The reins of *RayGun* magazine, the six-year-old legendary grunge-design-music rag, were handed over to designer Barry Deck when he joined as art director in 1998. His brief was to preserve the idiosyncratic, rebellious quality of the design while eradicating its unfashionable grunge aesthetic.

The designer remembers his experience at *RayGun* as being characterized by an acute lack of time and budgetary resources. Every month, between 70 and 100 pages of content needed to be designed in one week. This made for a highly creative and spontaneous design environment. He soon discovered that idiosyncratic, rebellious, grunge music writers don't adhere to deadlines. In any case, Deck had to honor the deadlines, because the company didn't get paid for any of the featured advertising until the issue hit the newsstand. For many designers it would be a dream job even though the constraints of budget were apparent. The paper was cheap, and the photo and illustration quality varied wildly, mainly because *RayGun* never paid its photographers or illustrators. These collaborators obviously had to make a budget decision of their own, forgoing financial payment for a chance to express their creativity and be featured in such a high-profile magazine. Rather than commission the design of a custom typeface for the magazine, the designer, a well-known typographer in his own right, developed a proprietary typeface called Eunuverse, a synthesis of Eunuch and Univers. Every word of the issues he art-directed was set in that typeface. Only one weight could be completed in time for the first issue of the redesign, and that was Eunuverse Light. The logotype was a variant of Eunuverse Light and was slightly bolder. The logo was created by copying the "r" from the *RayGun* logotype, which, flipped and rotated, became a gun. A set of rules, which would change slightly with each new issue, was prescribed for the design of content pages. These rules would then inform the entire issue and, in turn, develop over subsequent issues to place the creative stamp of Barry Deck on *RayGun*.

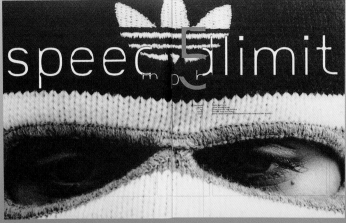

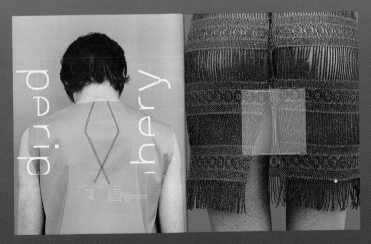

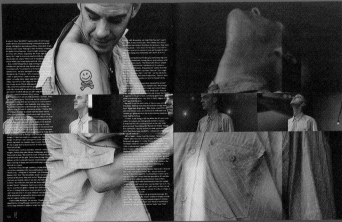

hompson,
renowned wit,
:laimed star of "Kids In The Hall"
 "The Larry Sanders Show"
d to interview Marilyn Manson Who
ve to say no?

Photography by Christian Witkin

First of all, I have to admit that I am not a professional journalist. I'm not even an amateur journalist. In fact, I've never even played a journalist in a movie, television show or sketch. So why am I writing this cover story on Marilyn Manson for Ray Gun then? I asked. You see, I just happened to have published a novel, *Buddy Babylon, The Autobiography of Buddy Cole*, and he just happened to be releasing a new album, *Mechanical Animal*, and I thought it would be a great way to publicize my book. You know, I thought I could mention it in the first paragraph. Done.

So, let me reiterate. I'm not a professional. I'm a performer too and Marilyn is a fan of mine. I have absolutely no journalistic objectivity and so everything you read must be taken with a grain of salt. I may have edited things that would have embarrassed Marilyn out of a sort of fellow-celebrity respect. Although, how anyone could embarrass Marilyn is beyond me. After all this is the man who has admitted to covering a groupie with luncheon meat and pissing on her, fisting a male fan as some sort of backstage right of passage and, finally, halfheartedly plotting the murder an ex-psycho-girlfriend. That's probably why I like him so much. Not so much for the acts—nobody should ever be covered with luncheon meat. No, it is the candor with which he approaches celebrity.

In his autobiography, *The Long Hard Road Out Of Hell*, Marilyn Manson gleefully describes situations which are so sordid that one can only wonder at his sanity. Not so much that he actually has done these things, but that he is so upfront about it. Come to think of it, both. In American popular culture there are always celebrities who are as famous for their behavior as for their work. Marilyn is one of them. Like Kurt and Courtney before him, he gives great copy. He is a journalist's pot of gold, the celebrity without brakes. Of course that's not always pretty. Look at Chris Farley or Farrah Fawcett. But Marilyn Manson (neé Brian Warner) is not a train wreck, but a train hurtling around a mountain pass very much in control.

I also should tell you that I know Marilyn Manson. Well, not exactly know. I have met him twice before. Once backstage in Toronto with my boyfriend at the time when they opened for nine inch nails, and once when I was sitting alone at Buzz Coffee in West Hollywood girding my loins for the gym. When he gamboled by with movie star Billy Zane, Marilyn looked a little tired, which could have been because he didn't seem to be wearing

Project
Strictly Bluegrass
promotional poster

Client
Strictly Bluegrass Festival

Design
Claude Shade

Claude Shade, a renowned art director from Goodby, Silverstein and Partners advertising agency in San Francisco, designed the second-year poster and advertisements for a local bluegrass festival—Strictly Bluegrass. The annual concert held in San Francisco's Golden Gate Park is free; so were the design and production. Enlisted by creative director Jeff Goodby for the project, Shade shared responsibility for generating the approach. They chose to depict a hillbilly bluegrass group en route from Kentucky to San Francisco by way of the latter's trademark cable car. For a pro bono project, this was visually ambitious. Traditional cable cars were unavailable and impractical for staging with a hillbilly crowd. However, there are mock-cable coaches on wheels that ferry tourists and parties around the city, so one was secured for a nominal fee. They then scouted for individuals with a hillbilly, bluegrass look. Given the budget limitations, they first sought fellow agency employees.

They chose six, but needed 15 as a minimum. Pro bono work is no less time-constrained than paid projects, so they enlisted a friend to cast characters who would serve with two days' notice for minimal cost. This netted five more hillbilly models. Finally they turned to friends to participate. All of the models were clothed in rented articles from the Salvation Army and secondhand shops and beards and wigs from costume shops.

Shot on an off-track cable car service parking lot, the vehicle was designed to appear as though it was on a long journey west, with one lookout person perched atop, wine jug in hand. Using a Polaroid photo of an actual cable car toiling uphill taken on the morning of the shoot, they matched the model car's angle to the one in the picture. The vehicle was only available for a few short hours, so they hurriedly piled the sparse luggage as high as possible on a cement loading dock to photograph from the angle of the real cable car. It took considerable scouting

to find landscapes to simulate Kentucky, and they were eventually found in the California area. They shot nine rolls of medium-format film and processed the images in the agency darkroom. After printing the best negatives, they used a desktop scanner to scan all the images at high resolution and brought them into PhotoShop to do the image assembly.

The composite image still lacked the necessary antiquated roughness the designer wanted to evoke. The image was scaled up as a large continuous-tone print of the digital file. This was mounted on foam core and rephotographed to generate another negative. An enlargement contacted onto photo paper produced an expansive paper negative, which was again contacted for a nice, textured print. The final scanned print was lined up with some personal glass negatives that were scanned for the final print's edges. With all this in place, they easily generated the type in Quark and the effects in PhotoShop.

Opposite
A poster representing a bluegrass music concert uses photomontage to create an original old-time-feeling image. Ambitious in its execution, it was achieved by combining different photographs and techniques and avoiding large location shoots.

Project
Alka Deployed

Client
konvex | konkav

Art Direction
Eikes Grafischer Hort,
Ralf Hiemisch

Design
Eikes Grafischer Hort

Illustration/Artwork
Eikes Grafischer Hort

Colors
CMYK

Eikes Grafischer Hort works constantly on visual concepts. These are then published internally and put up for discussion between the designers. In this way they create an environment of few restrictions and a lot of exploration and discussion. These concepts then find their way into their archives and are tested for applicability to up-and-coming projects. This way of working allows the designers to achieve tight deadlines, a high level of quality, and, at the same time, optimize the use of their resources.

Nothing is thrown on the scrap heap, and no draft is ever done in vain—at some point it may prove the inspiration for a new concept, as demonstrated by this project for konvex | konkav.

As part of the first phase, the designers spent a lot of time developing a beautifully crafted illustration. Unfortunately, the option was not suitable for the client, so it was archived. To make the most of the project budget, the second phase was presented as rough sketches. At this stage the team wanted to work out exactly what the client had in mind first, before spending time and money on more finished images. The client opted for an airplane-and-flight-based idea. With this idea, the designers worked out the entire concept and applied it to the individual elements, including vinyl, CD, display, and e-card. Meanwhile, the design team was commissioned to work for another client, who needed a piece of work done in a very short time. The designers found that the original option they presented to konvex | konkav and then archived was appropriate for this other client's project. The client agreed, resulting in Eikes Grafischer Hort fleshing out the entire concept and meeting the time requirement. For the designers, working economically does not mean calculating the cost of producing each project and having a surplus at the end. They see being economical as far more complex. Results that have met with their satisfaction conceptually and visually also exert an influence on the economics. Getting attention in publications, doing repeat business, and gaining new contacts and self-motivation through the realization of good ideas are reasons why the team, like many other designers, work on projects with small budgets and little financial reward for their services.

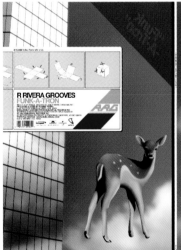
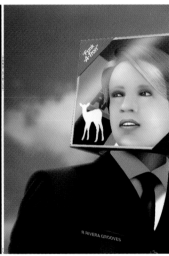

Above and opposite
This is the original illustration that was developed for konvex | konkav but was rejected and later used for another client. It is striking due to its surreal quality and its use of very pure and hyperreal colors.

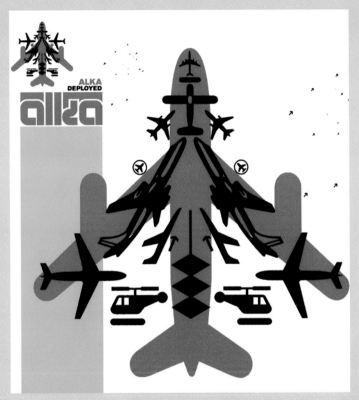

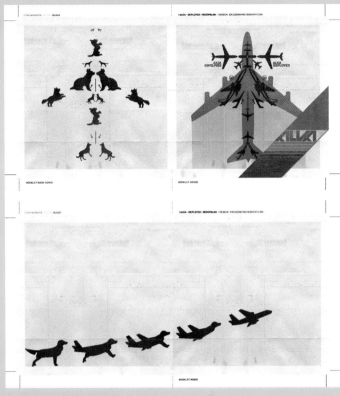

Above
After the first concept was declined, this concept, inspired by airplanes, was developed first as rough sketches before being drawn up. The graphic illustrations create a bizarre evolution from household pet to man-made flying machine.

Opposite
The design was extended to include vinyl, CD, display, and e-card.

Essay

**Pushing the Boundaries of
Print Budgets**
by David Arkell at The Colourhouse

Project
RAC Manual

Client
Royal Automobile Club
(RAC)

Design
North

Printer
The Colourhouse

The RAC (Royal Automobile
Club) manual is a brilliant
example of a design team
working with a printer, to
produce a great piece of
work, and keeping to a
budget without compromising
quality or creativity. There
is an excellent use of pin-sharp,
small images and creative
use of a Day-Glo special.
It was a huge book and,
because of constant
communication between
printer and designer, the
task was thoroughly enjoyable
for everyone involved and
ensured a successful and
high-quality product.

It was way over budget, but who cared!? That was how it used to be. Designers wanted something special, printers bent over backwards to do it—and everyone paid for it.

Technology has accelerated at an incredible rate, leaving a lot of printers behind (or facing major investment to catch up). Budgets had very few restrictions, allowing design agencies to choose the best printers even though they were often more expensive. There was a much bigger gap between the high quality printers and those in the division below. The designers' favorites were kept very busy with more difficult and challenging brochures.

Quality relied on the skill of the individual craftsman: scanning was a complex procedure and depended on the experience of the scanner operator, cutouts were produced with a scalpel, scans were laid down as individual color films, fit was down to the eye of the planner. Artwork was shot onto negatives and presses relied on the person at the front of the machine.

There was a lot more time to sit down, discuss, and resolve issues. The budget was there to pay for extras needed to improve the quality of a print project. Standards and service expectations are now higher; suppliers with up-to-date equipment are more on a level with each other. Quality of thinking differentiates one printer from another.

Today the craftsman's skill is less pronounced. Scans are pulled around on the system to achieve the designer's desire, cutouts are a simple procedure, color can be retouched quickly— previously impossible designs can be produced with relative ease. Designers often do the scanning themselves so the printer receives a complete file. Tighter budgets encourage the designer to involve the printer at an earlier stage in the process. All problems are tackled as a team. It is still a personal business; designers still like to use a printer they know and trust. The relationship between printer and designer is such that the printer will be told what price he has to do the job for. However with the budgets getting tighter and tighter, there is always someone out there who will do it more cheaply. Loyalty between printer and designer seems to be fading—designers can shop around for the better deals.

Budgets Can Be Maximized in a Number of Ways

A project is limited by a budget to a certain number of colors. The special colors on press can be maximized by reviewing each section on its own merit. For example, the first section can be printed in four-color process, three specials, and a varnish; the second section can be printed in three alternative specials; and so on, keeping the number of plates the same but using more colors throughout a brochure.

With experience, one or more of the process colors can be substituted with special colors. For example, Pantone 109 can replace process yellow, process blue can replace cyan, rubine red can replace magenta; high-density inks can also be used along with varnishes and paste. This generally results in a more saturated effect, but the printer needs the skills to make adjustments to images with skin tones and subtle midtones and take extra care over how brand colors are reproduced.

Simple but effective size adjustments, which tailor the brochure to press and finishing equipment, can often save money. Sometimes even a few millimeters deducted from one dimension can make a big difference to cost. This allows the designer to use the saving in more productive areas. The use of premium papers has been tempered. Both designers and printers need to be aware of suitable and cheaper alternatives. These are sometimes own brand sheets that are of a suitable quality but remain within budget particularly because they are not marketed by the paper merchants. Designers are responding creatively, too. They are using cheaper uncoated paper, often printed as one-color, and creative typography with fewer images. A good example of this is the Telewest annual review—a case-bound book with one-color text. A creative solution, giving a value-feel and making one-color text work very hard. Printers are investing in cost-saving equipment. To survive, they have to ensure there is very money leaking out of the system. We can no longer "chuck in" a free special or not charge for an extra 500 copies. Everything has to be accounted for, from a new machine part to a small courier charge.

Multi-information systems have been introduced to a lot of printers, linking the office, through reprographics to the print room and finishing. This ensures the job is quoted correctly, taking into account the number of sheets run per hour on press, folding, and binding. All these elements are constantly monitored to calculate the true cost of the quote. Scanners check the printed sheet throughout a job run, ensuring ink densities and fit remain constant to the pass sheet, thus reducing the risk of human error causing unnecessary reprints and other cost wasting. ISO 9002 is an essential qualification for every printer. It enables the printer to set up his or her own quality-check systems, which will reduce paperwork and ensure jobs run smoothly, ironing out any unnecessary and costly mistakes.

It is healthy for printers when designers push the print boundaries. It elevates those who can be inspired to a level above the "jobbing" printer. A good printer knows that an excellent job will not only guarantee repeat business from the designer but will also attract others.

It is a challenge to continue to produce high quality and innovative brochures on a decreasing budget. The quality of thinking that goes into a project long before ink meets paper makes the difference: good people are key. Reducing costs while retaining value is a balancing act, but one in which those who do well will continue to thrive.

Project
Postgraduate promotional
materials for the Faculty of Art,
Design and Music (2001-2002)

Client
Faculty of Art, Design and
Music, Kingston University
(London)

Project Manager
Teal A. Triggs

Production Manager
David Wood,
External Affairs,
Kingston University

Design
Joe Ewart and
Niall Sweeney for Society

Copy Writing
Teal A. Triggs

Printing
Futura Printing, London
K&N Printers, Surrey

Dimensions
23.75" x 15"
59.4 cm x 40 cm

folding twice to
11.8" x 7.8"
29.7 cm x 20 cm

Colors
Black plus one
Pantone color

Materials
Munken Print Extra 15, 150 gsm
Horizon 135 gsm

Colleges and universities, like all national education establishments, have to adhere strictly to their yearly budgets. This was no different for the faculty of Art, Design and Music at Kingston University.

The faculty needed a coherent postgraduate identity for a diverse portfolio of specialist subject-based courses, ranging from music, fine art, design, film, and television to surveying and architecture. This new identity had to cater to a diverse audience, including recent graduates, practicing artists, designers, musicians, and professional surveyors and architects. The faculty wanted not only to secure more students as a strategy for underpinning a developing research community but also to reflect the high quality and professionalism offered by its portfolio of courses. Avoiding a typical faculty brochure, the designers developed multipurpose, double-sided A2 posters for each of the many courses. The posters have a playful and dynamic optical effect, which is created by the bold use of stripes, panels, and strident colors. This graphic structure provides both the identity and a flexible visual framework for the substantial amount of course information. All of the posters use black and one other Pantone color in an effort to keep production costs minimal. Originally the designers wanted to use Munken, an uncoated stock, but its availability under the time and budget constraints was limited so they changed to Horizon, a similar and equally effective stock.

The patterns and type shout out, calling for you to look and read them. The multipurpose nature of each poster allowed them to be used in many ways, replacing the need to produce other collateral. As well as being folded down to A4 size and mailed in standard envelopes, they can be lined up next to each other to create a striking wall of shape, color, and typography.

Below right

The posters were designed so that, when put side-by-side, they create an ongoing pattern of shape, type, and color.
In this way, they create a bold and unmistakable graphic call to action.

Below left

The posters were folded so that the mailing process was more cost-effective.

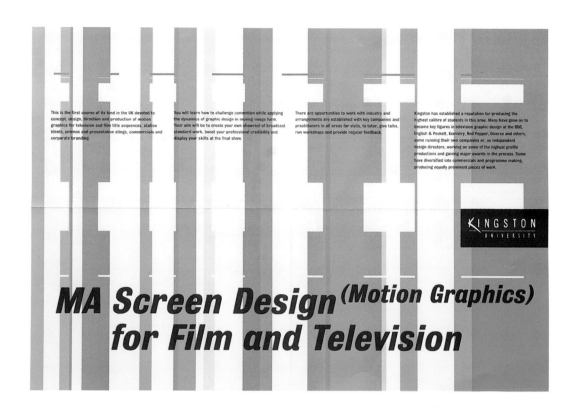

This is the first course of its kind in the UK devoted to concept, design, direction and production of motion graphics for television and film title sequences, station idents, promos and presentation stings, commercials and corporate branding.

You will learn how to challenge convention while applying the dynamics of graphic design in moving image form. Your aim will be to create your own showreel of broadcast standard work, boost your professional credibility and display your skills at the final show.

There are opportunities to work with industry and arrangements are established with key companies and practitioners in all areas for visits, to tutor, give talks, run workshops and provide regular feedback.

Kingston has established a reputation for producing the highest calibre of students in this area. Many have gone on to become key figures in television graphic design at the BBC, English & Pockett, Kemistry, Red Pepper, Diverse and others, some running their own companies or, as independent design directors, working on some of the highest profile productions and gaining major awards in the process. Some have diversified into commercials and programme making, producing equally prominent pieces of work.

KINGSTON UNIVERSITY

MA Screen Design (Motion Graphics) for Film and Television

Project
Contemporary Japanese
Jewellry

Client
Crafts Council

Design
Cartlidge Levene

Photography
Exhibition photos:
Richard Learoyd

Printing
Lithography:
Good News Press

Wall graphics:
McKenzie Clark

Digital printing:
1st Byte

Typeface
Helvetica

Materials
GF Smith Colourplan

Right
The graphic simplicity of
the design invites the recipient
to read the copy, giving the
message more importance
than the design.

Opposite
The reverse of the two-sided
poster is purely typographic.
The structured layout breaks
down the information into its
key components with the
larger text providing the
overview while the smaller
text provides the details.

Cartlidge Levene was asked
to produce exhibition graphics
for a touring Crafts Council
show of contemporary
japanese jewelry. This was
to include a cabinet-labeling
system, a gallery guide with
dispenser, wall graphics and
photographs, an information
area, and a learning area
with feedback facilities.
All of the items produced
needed to be dismantled
and be mobile, because the
show was to appear in three
venues across the country.
One criterion was that this
was all to be produced on
a limited budget.

The main graphic challenge
was to design a flexible
labeling system for display
cabinets, designed by Stickley
and Coombe Architects, that
would allow for moving the
jewelry pieces and labels right
up to the last moment before
the show opened. A system
of folded paper labels, which
could be moved along a paper
track to the exact position and
held in place by the weight of
the cabinet cover, was the
final solution.

A gallery guide was produced
to explain the work in the
show. This worked on several
levels. A single sheet was
printed in two colors with a
poster graphic on one side
and the guide information on
the reverse. A block of these
sheets was then bolted to
the wall, poster side facing
out. A perforated line below
the bolts allowed visitors to
tear off an individual sheet
and take it around the show
with them. Fold marks on
the paper helped the visitor
to then fold down the sheet
if they wished.

An information and education
zone was set up in one corner
of the gallery. This zone used
a system of clips, bought from
MUJI (no Japanese connection
intended—they simply looked
the best) onto which response
cards, photographs, and other
related material were attached.
Books were held down onto a
bench that ran through this area
with white seat belt strapping.

The color burgundy was used
throughout the gallery to
connect all of the graphic
material. Particular attention
had to be given to this as
the designers needed to
match paper color, litho print,
digital print, large-format wall
graphic outputs, paint, and
on-screen color. GF Smith's
Colourplan paper Burgundy
was the benchmark color
and everything else was
matched to it.

現代
日本の
ジュエリー

Contemporary Japanese Jewellery!

01 Which piece of jewellery in the exhibition surprises you most, and why?

Project
Hardcore

Client
Scarlet Projects

Design
Graphic Thought Facility

Right
While the show graphics were in production, the designers had time to resolve the issues with the Seriliph process and were able to apply it to some prototype and slightly tongue-in-cheek products for show within the exhibition.

Opposite
Their original thoughts were to investigate casting three-dimensional numbers in concrete to see how the casting process, along with other concerns such as weight, strength, and stability, would inform the typography. However, the supplier best suited to help with the casting was already donating time to the exhibition designers, so they looked to Pieri for this process.

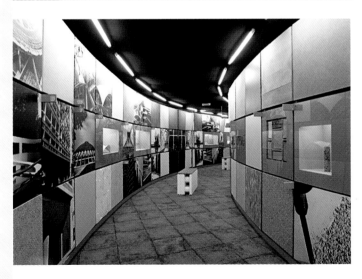

Graphic Thought Facility (GTF) does exhibition jobs because they enjoy exploring media other than print and working in teams with designers they respect from other disciplines. This job appealed on both criteria. They usually find that it's not necessarily the size of the budget per se but the exorbitant amount of time these jobs can potentially take that often makes exhibition work not viable commercially.

The designers wanted a graphics system that would work across the entire exhibition, which spread over two galleries with differing display mechanisms and differing levels of interpretation. The goal of the system was to physically realize the graphics using concrete, as well as to avoid the inevitable last-minute stress of setting, correcting, and placing caption texts. If they could achieve this outcome it would not only be cost-effective but memorable, too. GTF started thinking about a system of numbers created as objects made from concrete, with the interpretative text carried on a separate handheld sheet. They were very excited about the idea of producing graphics in concrete but knew it could be time-consuming to pursue all potential avenues with this medium. They made the decision to work within the areas of expertise of the various concrete companies who had pledged support, particularly work-in-kind,

to the project. This led to GTF contacting Pieri, a company that, along with architectural firm Hertzog de Muerer, had developed a technique for rendering halftone images permanently in concrete. This seemed a promising route to explore. They started to develop a font that would make good use of the halftone process. These were to be rendered in small blocks of concrete that could be freely positioned within the show. At the same time, they had begun working with the handheld text and soon realized that there was too much copy for a broadsheet of a practical size. In looking for a practical and inexpensive format that could clearly present a large volume of information, the team spoke to a paperback book printer and found they could afford to use something akin to the format of a novel.

The initial prototypes they received from the Pieri factory in France were disappointing, with poor definition in the characters. They didn't seem to be getting to the bottom of the problem quickly enough to guarantee meeting the graphics deadline, so GTF made the decision to silk-screen their custom font onto blocks of a lightweight, cuttable, concrete/board hybrid. They also took the size and scale of the typography on the blocks and applied it to all of the print materials for a very clear follow-through.

Project
Self-promotion

Client
Self-promotion

Designers
Nathan Collins,
Brian Barrett, Nin Bose,
Matt Durston

Typeface
Fette Fraktur

Colors
"Parachute Rino":
cream and blue on blue
dusk; mint and green
on olive

"Jet Panes":
light and dark green
on olive; mint and green
on blue dusk

"Beardy Man":
black on charcoal;
black on tan

"Fat Man":
cream on pine; dirty
brown on blue dusk

"Nipple Dial":
light blue on blue
dusk; mint on olive

"Luck Bird":
salmon and black on
aubergine; mint and
black on olive

Right
Daddy puts a fresh spin on a
self-promotion. The
simplicity and accessibility of
a T-shirt is used to great
effect. Strong, direct graphic
illustration and Germanic
typography represent
esoteric messages to
capture attention. The
designers used a powerful
but limited palette of colors
to help reduce the
production costs.

Having establishing Daddy soon after leaving college, the team thought that after eight years it would be a good idea to finally address the age-old killer—some self-promotion. Surviving on word-of-mouth recommendations for many years, they felt it was time to actively seek business. "The world is our oyster. Right? Let our creative genius go kicking down doors. Surely, unsheathed, our ideas could flourish in their true, undiluted glory," proclaimed the designers.

The solution? Back to basics. Forget the brochure, forget the clever folding and beautiful Italian paper. What can be done with very little money? T-shirts. T-shirts with their logo on them. Nothing else. A simple, clean, one-color screen-print.

Inexpensive, cool, honest, no-nonsense self-promotion. The reasoning went: If clients are prepared to wear a designer's work on their chests, then the battle's won. Daddy is figuratively invited into the client's home, wardrobe, and bedroom. How much more intimate a relationship could you have? Secondly, and most crucially, this was a great test of Daddy's own image. If they are in the business of building and improving brands and identities, then here was the chance to put their money where their mouth was.

They produced a short run of Daddy-branded T-shirts. After playing with a number of ideas at varying levels of complication and cost they reverted to the cheapest option, which happened to work in their favor. They stripped away any semblance of fuss or effort—no ideas, no clever message, just their logo, their name, in white on a khaki-green T-shirt. Daddy, laid bare, naked. Feedback came thick and fast, and the greatest sidebar story was of someone at the airport in Amsterdam being pulled aside by two customs officials, only to be asked, "Where'd you get the T-shirt? Very cool."

Building on the simple beginnings, the designers asked "Why not see where this takes us?" They then developed their first collection consisting of 16 designs, exhibited them at a fashion trade show, and took orders across Europe. They are now represented in Japan and have designed an exclusive range for Harvey Nichols, the prestigious United Kingdom department store. After encouraging media interest, the designers set up the whole merchandising idea as a separate business.

From an inexpensive design company self-promotional idea they now have what appears to be a coveted fashion label on their hands.

Project
destination soletrader

Client
soletrader

Design
Un.titled

Illustration
Un.titled

Copy Writing
soletrader/Un.titled

Reprographics
Phoenix Print

Printing
Phoenix Print

Print Run
200

Dimensions
Various

Typeface
Helvetica

Colors
Black and cyan

Materials
200 gsm matte art board
jiffy envelope
CD
Rubber stamp

Opposite
Direct mail packaging and
CD-ROM. The package uses
a pastiche of airline industry
design and identity to create
a direct and immediate look.
It includes a ticket folder and
CD-ROM covering the range
and background of the
company and its products.

Right
An easily sourced padded
envelope that is rubber
stamped for branding is an
immediate and easily
recognizable signifier of the
soletrader identity.

As a project with a limited budget, the soletrader CD-ROM actually offered Un.titled unlimited opportunities. The brief was to raise, update, and strengthen the profile of soletrader, a designer clothing retailer who, despite many recent shop refits, were finding it difficult to shake off an image they had gained during the '90s. The proposed audience for soletrader was very small and well targeted—fashion press, major brands, and the owners of the biggest shopping centers across the United Kingdom—so the impact needed to be as large as possible. Un.titled's response was to generate a completely different identity from the one existing design and redefine the way the company is viewed.

Tackling the identity with a fresh perspective, the designers created an identity and packaging that was a pastiche of the airline industry. By incorporating the branding onto a CD-ROM, they further strengthened the authenticity of the product. During the development stages the designers put together a number of samples from airlines that were used as models for both the design style of the packaging and the tone of the writing. The packaging style was to be unfussy, professional, and stylish. The designers chose one strong color that worked well both on screen and in print, which helped to reduce printing costs. Traditional printing methods were used for the wallet and luggage label, with a matte laminate added for a feeling of quality. Digital printing was then used for the luggage sticker and the ticket. This allowed for personalization of the tickets using a database of recipients, again strengthening the concept.

The CD-ROM was also printed with the brand color and identity. An inexpensive and readily available blue jiffy bag was sourced to mail the product and branded with a rubber stamp they had made of the logo—it was the cheapest element of all, but one that added a lot to the finished product.

A multimedia aspect to the project further enhanced the prestige while being very cost-effective and adaptable. The interactive navigation was based on a scrolling airport lobby with views of the runway outside. Costs were kept to a minimum by presenting the concept almost entirely with illustration that was generated in-house. The potentially expensive area of development—sound design—was helped by sourcing the majority of samples from a number of free sound libraries on the Internet.

SOLETRADER
EI 326748

DST

UNITED KINGDOM

BE 703

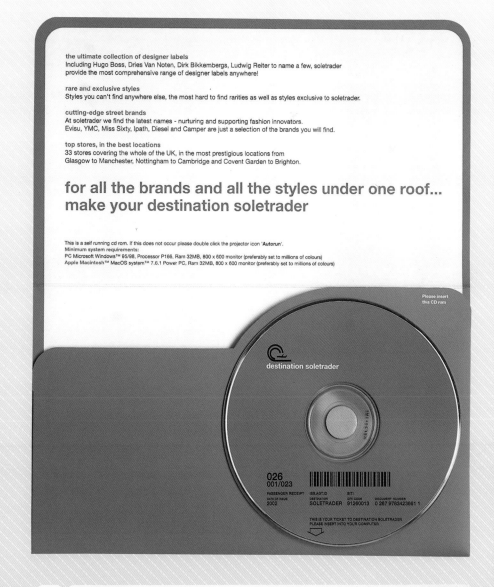

the ultimate collection of designer labels
Including Hugo Boss, Dries Van Noten, Dirk Bikkembergs, Ludwig Reiter to name a few, soletrader
provide the most comprehensive range of designer labels anywhere!

rare and exclusive styles
Styles you can't find anywhere else, the most hard to find rarities as well as styles exclusive to soletrader.

cutting-edge street brands
At soletrader we find the latest names - nurturing and supporting fashion innovators.
Evisu, YMC, Miss Sixty, Ipath, Diesel and Camper are just a selection of the brands you will find.

top stores, in the best locations
33 stores covering the whole of the UK, in the most prestigious locations from
Glasgow to Manchester, Nottingham to Cambridge and Covent Garden to Brighton.

for all the brands and all the styles under one roof...
make your destination soletrader

This is a self running cd rom. If this does not occur please double click the projector icon 'Autorun'.
Minimum system requirements:
PC Microsoft Windows™ 95/98, Processor P166, Ram 32MB, 800 x 600 monitor (preferably set to millions of colours)
Apple Macintosh™ MacOS system™ 7.6.1 Power PC, Ram 32MB, 800 x 600 monitor (preferably set to millions of colours)

Please insert
this CD rom

destination soletrader

026
001/023
PASSENGER RECEIPT ISS.AGT.ID SITI
DATE OF ISSUE
2002 DESTINATION OFF CODE DOCUMENT NUMBER
 SOLETRADER 91260013 0 267 9783423661 1

THIS IS YOUR TICKET TO DESTINATION SOLETRADER
PLEASE INSERT INTO YOUR COMPUTER

PASSENGER TICKET & BAGGAGE CHECK
SUBJECT TO CONDITIONS OF CONTRACT

| | | PASSENGER RECEIPT 1 OF 1 | ISS.AGT.ID | SITI |
ISSUED BY: | DATE OF ISSUE | ISS.OFF.CODE | ISO |
SOLETRADER (LONDON/UK) | **2002** | **91260013** | **GB** |

NAME OF PASSENGER (NOT TRANSFERABLE)
Footwear Enthusiast

ENDORSEMENTS/RESTRICTIONS
**VLD BE ONLY NON REF NON CHGE
NON END**

FORM OF PAYMENT
NON REF

PNR CODE
M421 TG/1G

STOCK CONTROL NO.
9547882109

DOCUMENT NUMBER
0 267 9783423661 1
DO NOT MARK OR STAMP IN
THE WHITE AREA ABOVE

NAME OF PASSENGER
Footwear Enthusiast

CONTACT DETAILS
**SOLETRADER
TWINMAR HOUSE
MAXTED ROAD
HEMEL HEMPSTEAD
HERTFORDSHIRE
HP2 7DX**

T: 01442 241431
F: 01442 230760

TYPE E
PRINTED BY UN.TITLED DATA MEDIA DIVISION F814/1 - 60/07

OPATB 2

01 24 E3 326749

DOMESTIC DEPARTURES ONLY

Project
Puntogblu

Client
Divinazione

Design
The Brainbox

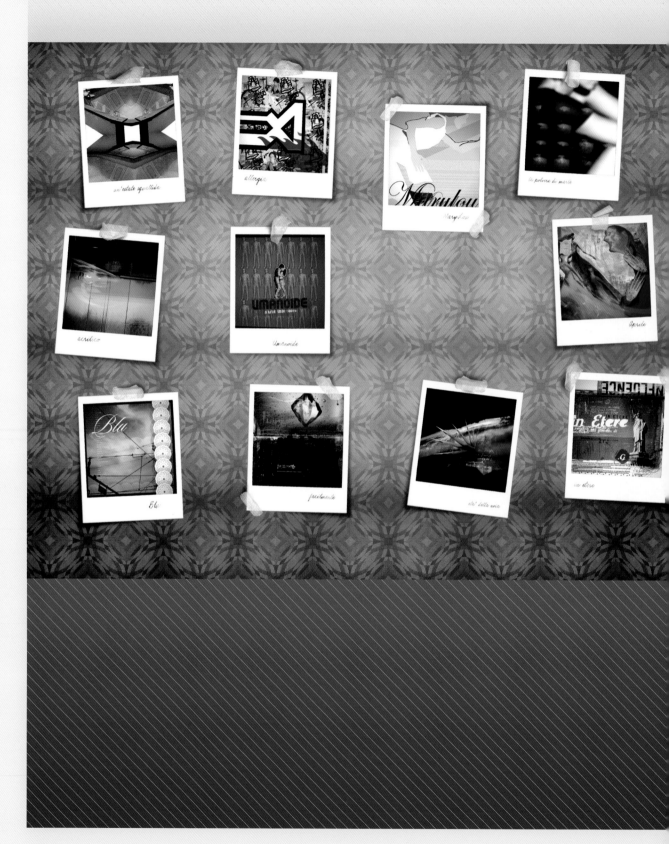

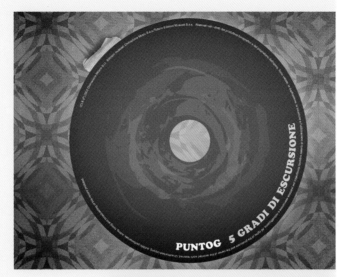

Italian design team The Brainbox was approached by independent record label Divinazione to design a CD and packaging for Puntogblu, an emerging young rock band. As The Brainbox team was already friends of the band, the design process was driven by the creative freedom this friendship offered. As a way to create a more memorable and practical design with minimal resources, The Brainbox called upon 10 other Italian designers to collaborate on the project, breaking the design work into smaller bite-sized pieces, with each designer creating an image inspired by one of the album tracks.

The Brainbox created a visual holding device that would display the designs. Each of the 11 individual designs is housed in a Polaroid picture frame and then stuck as a set to an old wallpaper surface to create the cover image. Using a combination of Polaroid and digital images, they montaged a single image to reflect the contrast between the 11 designers' modern design sensibilities and the music's more retro sound. Each of the images of the band, textures, and the Polaroid frames were shot digitally and then montaged with a distressed and aged color palette. The designers faded the images to create a vintage feel that sits well with the attitude and approach of the band's music. The use of found objects, existing settings, and a little ingenuity with photomontage created a seamless series of images that flow through the CD.

Opposite
The cover is a clever interplay between the expression of 11 different designers and the need to have a strong cohesive cover image. The result is a compelling image; although it appears to be vintage, it is a very modern technique lending the design a timeless quality.

Above left
The reverse of the cover is a simple visual pun to show the band.

Above
The CD booklet and case continue the tactile quality of the design. Sketches, wallpaper, and snapshots are used to create a vintage vernacular that is a clear development from the cover approach.

Project
IdN V9: N2/Build flash-
activated magazine cover

Client
IdN (International
Designers Network)

Design
Michael C. Place/Build

Typeface
Univers 65 Bold

Colors
Pantone 441 and
phosphorescent ink

Process
PMS 441 overprinted
with phosphorescent ink

Opposite
Using only two colors
to create the cover, the
designer has succeeded
with a memorable piece
of design on a number
of levels. The use of light-
reactive phosphorescent
ink not only has a tactile
quality but also invites the
reader to activate it using
flash photography.

Right
The layouts within the
magazine continue the
aesthetic approach
developed by the designer
on the cover. The use of
camera iconography
cleverly crosses the
language barrier that the
designer faced when
creating these pages on
the theme of photography.

Build, based in London, was commissioned to create a magazine cover for *IdN* Volume 9: Number 2 photo graphics issue and three double-page spreads. Based in Hong Kong, the edition would be Asian language only. Rather than do the obvious for a photography issue (i.e., use a photographic image), Build decided to look at a variety of camera manuals and find icons that are universal to more than one make of camera. Taking this approach allowed the designer to cross any language barriers with the use of universally understood iconography. Familiar graphics, such as a film rewind icon, a timer icon, and battery icons, were then reinterpreted and arranged on the cover. Instructions on the cover, "Compose, Focus, and Shoot," are intended to aid the end user in the operation of the design.

Build chose to limit the design of the cover to one color and a phosphorescent ink that glowed in the dark. The phosphorescent ink, when printed, gives an eggshell-type texture to the page, is slightly yellow in appearance, and looks completely different under low-light to zero-light conditions. This gave the design three different appearances and tactile qualities from one ink, which suited the budget. The idea for using the phosphorescent ink stemmed from encouraging the end user to activate the cover by using a camera with a flash, hence, the additional instructional text, "To activate this cover use flash photography." This not only reinforced the photographic theme but also invited the reader to go one step further in their level of interaction with the design.

IdN

Compose, focus + shoot

V9:N2
To activate this cover use a flash
photography*

Project
Last FM online portal

Client
Self Initiated

Designers
Michael Breidenbruecker,
Felix Miller, Martin Stiksel,
Thomas Willomitzer

Typefaces
Vt100, Helvetica, and Arial

Technology
Java, Php, Oracle, SQL,
Javascript, and HTML

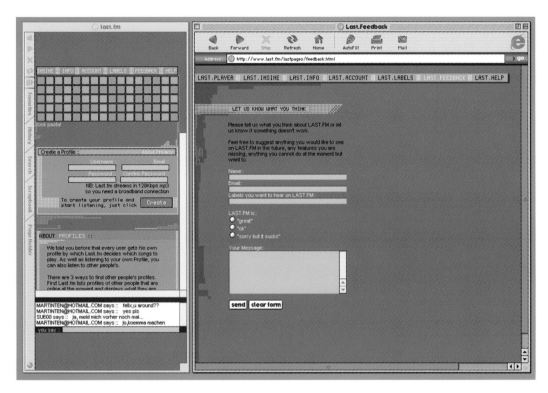

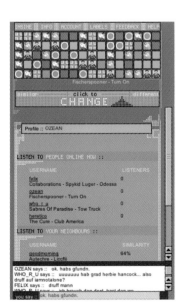

Last FM is an online music portal that offers music, similar to a radio station. Unlike a radio station, however, it has intelligent software that tracks the users' musical preferences. These preferences are stored and matched against a huge database of music so that users can learn about new music and share their taste with others.

The designers of Last FM considered themselves a team that was actually looking for rock-band fame but through circumstance ended up creating on the Internet. As the big Internet boom was over they had to create it without any money, just to make a point.

So there was no money, which contributed to a very sharp concept and design. There was no client, no investor, nothing hanging over their heads, just the team shouting out their message. Just like the rock band they wished to be. Direct delivery, straight and true. This started with the strategy and concept behind Last.FM and ended with the information design at the front of Last FM.

While creating the site, the energy level in the team was the opposite of the amount of money they were getting for their work. They had never worked as a more motivated and energetic team than in Last.FM, regardless of budget.

Last.FM is a bit of technology, a growing amount of good music, and, most important, the user.

Above top
The Web site for Last FM is a functional and robust information system that allows user interaction to develop and change an ongoing radio audio stream.

Above
Initial sketches that explore the user interaction and information flow of the portal.

Section Three
Resources

Above
Project 52 by Build

IN SIGHT: MEDIA ART FROM THE MIDDLE OF EUROPE **aims to illustrate contemporary concerns in media art, particularly in Poland, Hungary, Romania, and Slovenia. Contrary to the popular perception of the whole region as a single entity, the art presented here testifies to the varying rate and degree of media art development in Central Europe. While the work serves as an introduction to the "insights" of media artists in the post-communist era, at the same time it is important to remember that most of the ideas presented here would not formerly have been tolerated by the authoritarian regimes.** In Hungary, despite the time-honoured history of experimen-

4

tal filmmaking at the Bela Balazs Studios, extensive investigations with video developed only in the eighties. The rapid progress in electronic media, however, was illustrated at the *SVB Voce* exhibition of video installations in 1991, where major works were presented by Hungarian artists. During the same brief period, Hungarian Television provided exceptional opportunities for artists and filmmakers by supporting eclectic broadcast programs. The three works by Péter Forgács, András Sólyom, and András Salamon included here are important examples of this interesting feature of Hungarian video production. Since 1993, however, the politics of the so-called media

5

Above
Project 32 by Concrete

Societies and Institutions

Designers have a special relationship with creative societies and institutions. The institutions have been created to help promote, develop, and represent the creative community, both locally and globally. They play an important part in maintaining and securing the presence of the creative industry within the wider culture. They provide the opportunity for designers to meet, discuss, and debate, as well as offer a diverse and educational calendar of events and exhibitions. The mutual benefit can be seen whenever a designer is commissioned to work with the institution. It is a privilege for both. The institution, generally having too small a budget to afford the caliber of designer had they been a commercial client with the same budget, gets that designer because he or she sees more than a financial reward. For the designer, the reward goes beyond money. Creative freedom without traditional commercial constraints is what he or she desires, and the institution is generally happy to oblige.

The following is a list, with contact information, of many creative institutions and societies around the world, a few of which have been kind enough to contribute to this book.

The Advertising & Design
Club of Canada
445 Adelaide St. W.
Toronto, Ontario
Canada M5V 1T1
T. +1 416 423 4113
www.theadcc.ca

American Institute of Graphic Arts
(AIGA)
164 Fifth Ave.
New York, NY 10010
T. +1 212 807 1990

The Art Directors Club (ADC)
106 W. 29th St.
New York, NY 10001
T. +1 212 643 1440
www.adcny.org

Australian Graphic Design
Association (AGDA)
P.O. Box 283
Cammeray NSW 2062
T. +61 02 9955 3955
www.agda.asn.au

Chartered Society of Designers
First Floor, 32-38 Saffron Hill
London EC1N 8FH
United Kingdom
T. +44 (0) 207 831 9777

D&AD
9 Graphite Square
Vauxhall
London SE11 5EE
United Kingdom
T. +44 (0) 207 840 1111
www.dandad.org

Design Austria
Kandlgasse 16
A-1070 Wien
T. +43 1 524 49 49 0
www.designaustria.at

Design Council
34 Bow St.
London WC2E 7DL
United Kingdom
T. +44 (0) 207 420 5200
www.design-council.org.uk

The Design Museum
28 Shad Thames
London SE1 2YD
United Kingdom
T. +44 (0) 207 403 6933

Designers' Institute of
New Zealand
P.O. Box 5521, Wellesley St.
Auckland, New Zealand
T. +64 (9) 303 1356

Icograda, International Council
of Graphic Designers
Icograda Secretariat
P.O. Box 5, Forest 2
B-1190 Brussels
Belgium
T. + 32 2 344 58 43
www.icograda.org

Internationales Design Zentrum
Berlin
Rotherstr. 16/Warschauer Platz
10245 Berlin
T. +49 30 29 33 51 0
www.idz.de

Italian Graphic Arts Institute
via Zanica 92
I-24100, Bergamo, Italy

Japan Graphic Designers
Association Inc.
www.jagda.org

National Institute of Design
Paldi
380 007, Ahmedabad, India
T. +91 (79) 79692

Society of Graphic Designers
of Canada
GDC National Secretariat
ArtsCourt – 2 Daly Ave.
Ottawa, Ontario
Canada K1N 6E2
T. +1 877 496 4453
T. +1 613 567 5400
www.gdc.net

Society of Typographic Designers
Chapelfieid Cottage
Randwick
Stroud GL6 6HS
United Kingdom
T. +44 (0) 1453 759 311

Swiss Graphic
Designers Association
Limmatstr. 63
CH-8005, Zürich, Switzerland

Vendors

When working with a limited budget, it becomes even more important to know who can help find a clever solution, whether determining a printing method, sourcing a particular material, or finding an inexpensive method of binding a book. It relies on research. Many solutions, especially those that tackle restricted funds, are generally found outside traditional techniques. Often, everyday items can be repurposed to create clever and memorable solutions. The vendors that you work with are a key part of helping you achieve your conceptual and budgetary goals. They should be willing to embrace new ideas and look for new ways
of doing things. Many such vendors are now making a virtue of working to a budget. The constant requests from designers for new materials have led them to create libraries
of ideas, finishes, and processes. It is also worth remembering that your solution might lie outside of traditional vendors, such as printers and finishers. As in the case of the Graphic Though Facility project,
the solution was found by contacting a paperback book manufacturer instead of a traditional printer. By going to a vendor that already has the means to produce what you want, you can reduce costs substantially.

The following is list of vendors, some recommended by the contributors. However, this list should only be seen as a catalyst for your own library of resources. By continuing to research different avenues, from high street supermarkets to construction companies, as well as building relationships with traditional vendors, you will develop the resources you need to achieve solutions to meet your budget.

Printers:

Artomatic
13-14 Great Sutton St.
London EC1V 0BX
United Kingdom
T. +44 (0) 207 566 0171
www.artomatic.co.uk

Balding + Mansell
Saxon Group, Saxon House,
Hellesdon Park Rd.
Drayton High Rd.
Norwich NR6 5DR
United Kingdom
T. +44 (0) 1603 487 777

BEP Group
Unit 8, Barge Ct.
44-48 Wharf Ct.
London N1 7SH
United Kingdom
T. +44 (0) 207 336 8228

Chevalier
Nijverheidsweg 46
P.O. Box 210
3340 ae Hendrik ido Ambacht
Sweden
T. +31 78 683 3300

Colourhouse
Arklow Road Trading Centre
Arklow Rd.
London SE14 6EB
United Kingdom
T. +44 (0) 208 305 8305

Everbest
C5, 10F Ko Fai Industrial Building
7 Ko Fai Rd.
Yau Tong, Kowloon
Hong Kong
T. 852 2727 4433

Fernedge Printers
18 Colville Row
London W3 8BL
United Kingdom
T. +44 (0) 208 992 4895

Four Color Imports
2843 Brownsboro Rd.
Suite 102
Louisville, KY 40206
United States
T. + 1 502 896 9644

Gavin Martin Associates
KGM House
26-34 Rothschild St.
W. Norwood
London SE27 0HQ
United Kingdom
T. +44 (0) 208 761 3077

Mark Screenprinting
1608 N. Washtenaw
Chicago, IL 60647
United States
T. +1 773 342 6042
Email: mdrprint@aol.com

Photofit
Unit 1, Waterside
44-48 Wharf Rd.
London N1 7UX
United Kingdom
T. +44 (0) 207 336 8911

Rippon Printers
656 S. Douglas St.
Rippon, WI 54971-0006
United States
T. +1 800 321 3136

Rohner Letterpress
3759 N. Ravenswood
Chicago, IL 60613
T. +1 773 248 0800
bruno@rohner1.com

Royle Corporate Print
12 Old St.
London EC1V 9BE
United Kingdom
T. +44 (0) 207 253 7654

SOB
4949 N. Western Ave.
Chicago, IL 60625
United States
T. +1 773 271 0600
sobltd1@aol.com

Solways
P.O. Box 363, 5 Vine Yard
London SE1 1QL
United Kingdom
T. +44 (0) 207 407 2875

White Crescent Press
Crescent Rd., Luton
Bedfordshire LU2 0AG
United Kingdom
T. +44 (0) 1582 723 122

Typographers:

Dalton Maag
Unit M2, 245a Coldharbour Ln.
London SW9 8RR
United Kingdom
T. +44 (0) 207 924 0633

Exhibition and 3-D:

Small Back Room
88 Camberwell Rd.
London SE5 0EG
United Kingdom
T. +44 (0) 207 701 4227

Smoothe
Cairo Studios, 4-6 Nile St.
London N1 7RF
United Kingdom
T. +44 (0) 207 490 4300
www.smoothe.co.uk

Digital Printers:

Octopus
110A Warner Rd., Camberwell
London SE5 9HQ
United Kingdom
T. +44 (0) 207 274 0118

Product Design:

Tangerine
8 Baden Pl., Crosby Row
London SE1 1YW
United Kingdom
T. +44 (0) 207 357 0966

Paper Merchants:

Fenner Paper Company
15 Orchard Business Centre
Vale Rd., Tonbridge
Kent TN9 1QF
United Kingdom
T. +44 (0) 1732 771 100

GF Smith
2 Leathermarket, Weston St.
London SE1 3ET
United Kingdom
T. +44 (0) 207 407 6174

Hing Tai Hong Paper
1/F Chaiwan Ind. Centre
20 Lee Chung St., Chaiwan
Hong Kong
T. 852 2896 9597

Sappi
Nash Mill, Lower Rd.
Hemel Hempstead
Hertfordshire HP3 9XF
United Kingdom
T. +44 (0) 1442 418 000

Tailormade Paper Service
Sovereign House, Brackmills,
Northampton NN4 7JE
United Kingdom
T. +44 (0) 870 608 2385

Materials and Products:

Alloy Sales
Forest Business Park
South Access Rd.
Walthamstow E17 8BA
United Kingdom
T. +44 (0) 208 509 1166

AMG
100 South Worple Way
London SW14 8NG
United Kingdom
T. +44 (0) 208 878 7211

Folders Galore
The Windsor Centre
Windsor Grove, Crystal Palace
London SE27 9LT
United Kingdom
T. +44 (0) 208 670 7416

Fusion Glass Design
365 Clapham Rd.
London SW9 9BT
United Kingdom
T. +44 (0) 207 738 5888

Hi-Fi Industrial Film
Wedgewood Way, Stevenage
Hertfordshire SG1 4SX
United Kingdom
T. +44 (0) 1438 314 354

IC Holographic
71 Endell St.
London WC2H 9AJ
United Kingdom
T. +44 (0) 207 240 6767

Touchtone
53-79 Highgate Rd.
London NW5 1TL
United Kingdom
T. +44 (0) 207 267 1900

TSF Clothing
161E Sheen Rd., Richmond
Surrey TW9 1YS
United Kingdom
T. +44 (0) 208 332 2855

CD Replication:

Data Biz
Bankside, Kidlington
Oxford OX5 1JE
United Kingdom
T. +44 (0) 1865 852 100

Mock Up Services:

Hipwell Bookbinders
Rockleys, Church Rd.
Goldhanger, Maldon
Essex CM9 8AW
United Kingdom
T. +44 (0) 1621 788 459

Letterbox
White Bear Yard
144A Clerkenwell Rd.
London EC1R 5DP
United Kingdom
T. +44 (0) 207 837 8669

**Film and Television
Post Production:**

A52
9006 Melrose Ave.
Los Angeles, CA 90069
United States
T. +1 310 385 0851
www.a52.com

Fluid
532 Broadway, 5th Floor
New York, NY 10012
United States
T. +1 212 431 4342
www.fluidny.com

Riot Manhattan
545 Fifth Avenue
New York, NY 10017
United States
T. +1 212 687 4000
www.riotdesign.tv

Audio:

Amber Music
Ramillies Buildings, 1-9 Hills Pl.
London W1F 7SA
United Kingdom
T. +44 (0) 207 734 0023
www.ambermusic.com

Human
138 5th Avenue, 3rd Floor
New York, NY 10011
United States
T. +1 212 352 0211
www.humanworldwide.com

NBAW
Top Floor, 42-26 New Rd.
London E1 2AX
United Kingdom
T. +44 (0) 207 247 1872

Directory of Contributors

Above
Project 27 by Aboud Sodano

Abnormal Behavior Child
Nicola Stumpo
Via Canonica 82
70154 Milano
Italy
me@abnormalbehaviorchild.com
www.abnormalbehaviorchild.com

Aboud Sodano
Alan Aboud
Studio 26, Pall Mall Deposit
124-128 Barlby Rd.
London W10 6BL
United Kingdom
T. +44 (0) 208 968 6142
www.aboud-sodano.com

Autotroph
Barry Deck
barry@autotroph.com
www.autotroph.com

The Brainbox
Mauro Gatti
contact@thebrainbox.com
www.thebrainbox.com

Build
Michael C. Place
Michael@designbybuild.com
www.designbybuild.com

Büro X Wien
Günther Eder
Grosse Neugasse 1/5
A-1040 Vienna
Austria
T. +43 699 1189 5969
www.buerox.com

Cahan and Associates
Bill Cahan
171 Second St., Fifth Floor
San Francisco, CA 94105
United States
T. +1 415 621 0915
www.cahanassociates.com

Cartlidge Levene
Ian Cartlidge
238 St. John St.
London EC1V 4PH
United Kingdom
T. +1 (0) 207 251 6608

Concrete
Diti Katona
2 Silver Ave.
Toronto, Ontario
Canada, M6R 3A2
T. +1 416 534 9960
mail@concrete.ca
www.concrete.ca

Daddy
Nin Bose
35 Britannia Row, Islington,
London N1 8HQ
United Kingdom
T. +44 (0) 207 704 9878
nin@daddydesignlondon.co.uk
www.daddydesignlondon.co.uk

dixonbaxi
70 Borough High St.
London SE1 1XF
United Kingdom
T. +44 (0) 207 864 9993
www.dixonbaxi.com

EGO
215 Centre St., Sixth Floor
New York, NY 10013
United States
T. +1 212 226 8745
info@iheartego.com
www.iheartego.com

Eikes Grafischer Hort
Eike König
eike@eikegrafischerhort.com
www.eikesgrafischerhort.com

Eleethax
hack@eleethax.com
www.eleethax.com

Estudio Peon
Monica Peon
#64-int, 15, Col.Insurgentes
Mixcoac, CP 03920
Mexico DF
T. +1 525 583 04 38
peon@mexico.com

Goodby, Silverstein and Partners
Claude Shade
720 California St.
San Francisco, CA 94108
United States
T. +1 415 392 0669
contact@gspsf.com
www.gspsf.com

Graphic Thought Facility
Andrew Stevens
Unit 410, 31 Clerkenwell Close
London EC1R 0AT
United Kingdom
andy@graphicthoughtfacility.com
www.graphicthoughtfacility.com

h69.net
Hoss Gifford
hoss@h69.net
www.h69.net

David Jury
Sheepen Rd., Colchester
Essex CO3 3LL
United Kingdom
T. +44 (0) 1206 518 168
david.jury@colch-inst.ac.uk

Last FM
Martin Stiksel
Top Floor, 42-26 New Rd.
London E1 2AX
United Kingdom
T. +44 (0) 207 247 1872
www.lastfm.com
www.insine.net

MadeThought
Paul Austin
Second Floor, 181 Cannon St. Rd.
London E1 2LX
United Kingdom
T. +44 (0) 207 488 4005
www.madethought.com

Hamish Muir
hm@noname2.demon.co.uk

Misprinted Type
Eduardo Recife
recifed@terra.com.br
www.misprintedtype.com

Nocturnal
Mike Tomko
T. +1 480 889 0463
mike@greenmail.com

onemorethantwo
Ash Bolland
ash@onemorethantwo.com
www.onemorethantwo.com
www.phojekt.com

Orange Juice Design
Garth Walker
461 Berea Rd., Durban 4001
South Africa
T. +27 31 277 1860
garth@oj.co.za
www.oj.co.za

Pentagram Design
Michael Bierut
204 Fifth Ave.
New York, NY 10010
United States
T. +1 212 683 7000
www.pentagram.com

Pixelsurgeon
Richard May
rich@pixelsurgeon.com
www.pixelsurgeon.com

Pogo Technology Ltd.
Marcus Hoggarth
80 Clerkenwell Rd.
London EC1M 5RJ
United Kingdom
T. +44 (0) 207 961 4100
www.pogo-tech.com

Segura Inc.
Carlos Segura
1110 N. Milwaukee Ave.
Chicago, IL 60622-4017
United States
T. +1 773 862 5667
carlos@segura-inc.com
www.segura-inc.com

Struktur
Roger Fawcett-Tang
The Rookery, Halvergate
Norfolk NR13 3RZ
United Kingdom
T. +44 (0) 1493 701 766
roger@struktur.co.uk
www.struktur.co.uk

Tangerine
Michael Woods
8 Baden Pl., Crosby Row
London SE1 1YW
United Kingdom
T. +44 (0) 207 357 0966
www.tangerine.net

Tolleson Design
Steve White
220 Jackson St., Suite 310,
San Francisco, CA 94111
United States
T. +1 415 626 7796
www.tolleson.com

Teal A. Triggs
Faculty of Art, Design and Music
Kingston University, Knights Park
Kingston-upon-Thames
Surrey KT1 2QJ
United Kingdom

Vrontikis Design Office
Petrula Vrontikis
2707 Westwood Blvd.
Los Angeles, CA 90064
United States
T. +1 310 446 5446
pv@35k.com
www.35k.com

WeWorkForThem
Michael Cina
4274 Meghan Ln.
Eagan, MN 55122
United States
T. +1 651 452 9191
www.weworkforthem.com

Why Not Associates
Patrick Morrissey
22c Shepherdess Walk
London N1 7LB
United Kingdom
T. + 44 (0) 207 253 2244
www.whynotassociates.com

WIG-01
wig@wig-01.com
www.wig-01.com

Williams and Phoa
Clifford Hiscock
16 Regents Wharf, All Saints St.
London N1 9RL
United Kingdom
T. +44 (0) 207 837 5778

Yacht Associates
Unit 7, Stephendale Yard
Stephendale Rd.
Fulham SW6 2LR
United Kingdom
T. +44 (0) 207 371 8788
info@yachtassociates.com
www.yachtassociates.com

Zylonzoo
Rex Edward G. Advincula
zylonzoo@halfproject.com
www.halfproject.com

Mad Andy—Your shit is ——really weak.

Above
A detail from the dixonbaxi redesign of MTV2 television channel in the UK.

About the Authors

Simon Dixon and Aporva Baxi are the founders of the London-based design practice dixonbaxi. They have had a wealth of experience, having worked as creative directors in Europe, the United States, and Australia on projects as diverse as concept cars and television networks to directing commercials and designing a series of books. They have now settled down in the heart of the creative community of London where they divide their time between commercial work and their ongoing dixonbaxi graphic novel project, *Zero.* You can keep up with their progress at their Web site diary: **www.dixonbaxi.com**